HOW TO DRAW

MANGA STYLE

HOW TO DRAW
MANGA STYLE

ANNIE OBAACHAN

Search Press

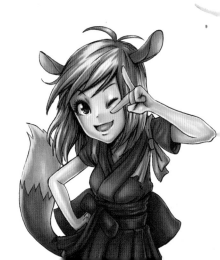

This edition published in 2012 by
Search Press Ltd
Wellwood
North Farm Road
Tunbridge Wells
Kent TN2 3DR
www.searchpress.com

A Quintet book
Copyright © Quintet Publishing Limited
All rights reserved.
QTT.DMAS

This book was conceived, designed, and produced by
Quintet Publishing Limited, The Old Brewery, 6 Blundell Street,
London N7 9BH, UK

Project Editor: *Asha Savjani*
Assistant Editor: *Carly Beckerman-Boys*
Editorial Assistant: *Holly Willsher*
Designer: *Rehabdesign*
Art Director: *Michael Charles*
Managing Editor: *Donna Gregory*
Publisher: *James Tavendale*

Printed in China by Midas Printing International Limited

ISBN-13: 978-1-84448-834-6
10 9 8 7 6 5 4 3 2

CONTENTS

Introduction **6**

1: What is Manga? **10**

2: Manga Styles **20**

3: Manga Characters **30**

4: Manga Genres **48**

5: Storytelling **60**

6: Special Effects **84**

7: Creating Worlds **110**

8: Character Design **122**

9: Showing Emotion **166**

10: Telling Your Story **172**

11: Looking To The Future **206**

Glossary **220**

Credits **221**

Index **222**

INTRODUCTION

Almost as long as 1,000 years ago, the very earliest examples of Japanese storytelling in picture form took shape in image sequences painted onto a scroll (a transportable length of paper that might be rolled, unrolled and then exhibited from place to place). The story material would have been popular imagery – boisterous humour, tales from mythology, epic conflicts – or 'bedside reading', suitable for a more private viewing. This ancient culture, existing unchanged for a millennium, largely disappeared during the course of the twentieth century, and many traditions and customs died with it. Rapid modernisation (the Industrial Revolution) aside, Japan's greatest upheaval was its defeat in the Second World War (1939–1945) when the United States dropped two atom bombs on the highly populated cities of Hiroshima and Nagasaki.

Between the years 1945 and 1952, American military forces occupied Japan. During this period, American comic books read by GIs fell into the hands of impressionable young Japanese who started to modify their own unique comic-book style.

Arising like a phoenix from the ashes, Manga as we know them today became a prominent feature of postwar Japanese culture. This was largely due to the popularity of the work of one man – Osamu Tezuka, the 'Father of Manga' (1926–1989).

A teenager during the war, his first Manga series was *Shin Takara-jima* ('The New Treasure Island') published in 1947. He went on to create many more, including *Tetsuwan Atomu* ('The Mighty Atom'), or *Astro Boy* in the United States and *Janguru Taitei* ('The Jungle Emperor'), known as *Kimba, the White Lion* in the United States, and said to have influenced Disney Studios' *The Lion King*. Tezuka himself took his inspiration from American cartoons such as Popeye.

Tezuka's modern, fast-moving approach to Manga was as different from what came before as cinema was to theatre. With many thousands of story pages still in circulation, his work and influence live on today.

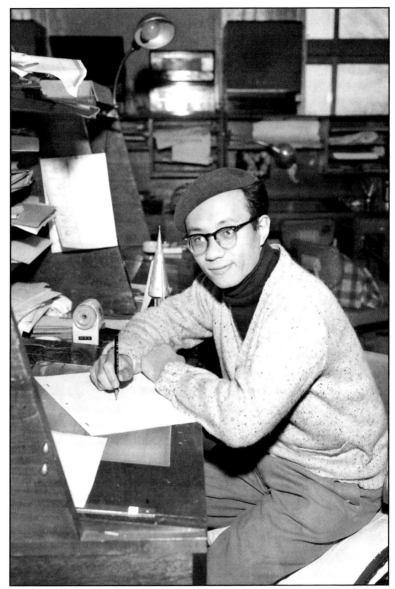

Osamu Tezuka, popularly known as the 'Father of Manga', in his studio in Tokyo, Japan, 1962.

MANGA INFLUENCE

For many years Japanese publishers did their best to persuade export markets that Manga was good for them. In order to please, they tried flipping the reading order of pages and colorising previously black and white artwork (with not-always-successful results!). The publishers concentrated their efforts on material they felt might be most easily understood – the Western-style cinematic Manga action of *Akira*, for example.

It was animation that led the way in encouraging an interest in Manga itself. Anime became more popular through the global reach of TV cartoons – an early marketing success was *Astro Boy*, and later *Gatchaman* ('G Force'). In recent years this momentum has been maintained with Manga-to-anime titles such as *Cowboy Bebop*, as well as the purely anime movies from Studio Ghibli, which produces a high standard of work.

Genuine growth has been relatively recent – the phenomenal success of Manga has sent sales skyrocketing to unprecedented heights. Unexpectedly this has been largely due to reader, and not publisher, demand. It was discovered that modern readers wanted their Manga to be kept to its original reading order ('backwards' to Western eyes) and original formats (small, black and white). As with most new trends it was the younger generation who were willing to try something new. Manga is like having a secret code and language, which is apparently difficult for adults to understand – and its readers are rightly proud of their expertise in this area.

THE MANGA 'REVOLUTION'

Manga's fashionable and ever-widening appeal has rock-solid foundations in its characters and story content. In its infinite variety, Manga caters to a vast readership, and people of every sort – but most significantly it has boosted the formerly poor ratio of female-to-male comic book readers (and creators). Over half the population has been missing from the equation since the heyday of the romance genre in comics half a century or more ago.

In truth we have barely begun to scrape the surface of what's possible, or to import and digest the vast wealth of material that has amassed across the ocean in Japan over the past 60 years. You ain't seen nothing yet, and that's the truth. Manga are here to stay.

Astro Boy, the Japanese Manga series first published in 1952, has since been turned into both a television series and an American 3D film.

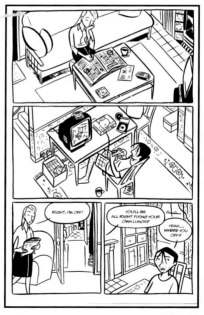

In this page from his serial *Breakfast After Noon*, Western *mangaka* Andi Watson displays a Japanese influence – not only from modern Manga, but in the use of deliberate flat perspectives seen in traditional Japanese scroll paintings.

CHAPTER 1

WHAT IS MANGA?

THERE'S MORE TO MANGA THAN CUTE GIRLS WITH BIG EYES. FIND OUT HERE WHAT EXACTLY MANGA IS AND WHAT YOU NEED TO GET STARTED DRAWING MANGA-STYLE.

THERE'S MORE TO MANGA

Many people think they know Manga – that it's about big eyes and cute girls and fantasy storylines. It is! But this is only one tiny part of drawing Manga-style, as this book will demonstrate. Manga is more than any single genre or style – it's an entire medium, like cinema or literature, but with the power of both.

This book explains the theory behind the practice – how Manga comics are produced and why they appeal to modern readers all over the world.

In creating Manga, many different skills are called into play – not only drawing but also storytelling (or narrative). This book reveals the inspiration behind successful character design, panel composition and page layouts, as well as guiding you, step by step, through the basic drawing skills required.

Examining the various styles of authentic Japanese Manga – *shojo*, *chibi* and *mecha* – you will soon arrive at your own original designs and storylines. No two Manga need look alike!

WHAT IS 'MANGA'?

Manga is the art of the comic strip – Japanese-style. In Japan, the habit of reading comics (Manga) is much more widespread than in the West – they account for a quarter of all publishing in Japan. As well as the inevitable book collections of the most popular strips, there are thousands of different weekly comic titles. Before a storyline finishes, it may run to many thousands of pages. It's hard for us to imagine the popularity of comics on this level.

In recent years Manga have started to gain popularity in the West, mostly among the young. We live in exciting times. This is just the start of a Manga explosion within our own culture. Soon, they will be everywhere.

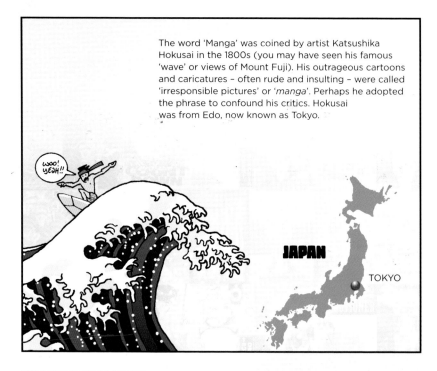

The word 'Manga' was coined by artist Katsushika Hokusai in the 1800s (you may have seen his famous 'wave' or views of Mount Fuji). His outrageous cartoons and caricatures – often rude and insulting – were called 'irresponsible pictures' or '*manga*'. Perhaps he adopted the phrase to confound his critics. Hokusai was from Edo, now known as Tokyo.

TURNING JAPANESE

There's an art to reading original Japanese Manga, even once they have been translated. Japanese comic pages read from top to bottom, like our own. But, instead of going from left to right, both pages and panels read from right to left – the exact opposite of the way we read in the West.

And this is just the first of many differences to be found in Manga, as we will see. Translated editions sometimes flip the pages horizontally (as if reflected in a mirror) so that they read left to right, but this doesn't always work. These days (due to popular demand) most stay back to front, as with the original Japanese Manga – and the readers do the flipping.

To avoid confusion we will stick with making our own Manga Western-style, working – and reading – from left to right.

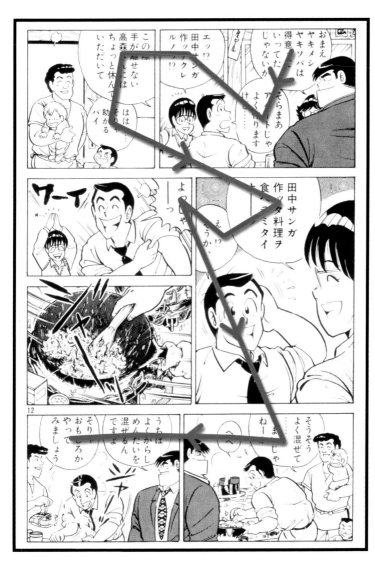

The typical reading order of panels and speech balloons in Manga is very different to that seen in Western comics.

BASIC KIT

Respect the pencil! In the land of comics, the mighty pencil is King. Everything else is about making pretty pictures – but your pencil is pure thought. It's the channel from your brain direct to the page, and from your page to the rest of the world. With it you will lay down your plans for world domination!

Other materials you may need and their applications will be discussed in more detail as we progress to more complicated techniques, but for now here's a list of some items it might be worth sourcing (see page 17).

Once you start to develop your own drawing style, you'll soon discover what extra materials you need. Start saving, and be prepared to do some shopping!

You will need two ink pens, one thin and one thick, with which to ink in your pencil drawings. You should use these to finalise your Manga artwork for the best reproduction or printing. The details of this will be discussed later. Try them out right now, experimenting with other materials until you get used to handling them.

The basic truth is, to create Manga you need very little, so there's no excuse not to get going! At the end of the day all you need is the will, a mark maker, and a surface to mark on.

Before you start drawing, you need to prepare your work space. This is often as important as your materials and equipment, so take your time finding a comfortable place, whether it's in the privacy of your own room or tucked away in the corner of your den.

TIP: Many professionals first lay out their images with blue pencils. Unless you draw with a very heavy hand, a blue line is invisible to most photocopiers and scanners, if you first set them to 'line art'.

The only thing that beats the mighty pencil, be it ordinary or graphite blue, is the crafty eraser. The trick is that most of the time you don't have to erase blue line drawings. However, you will be using graphite (or 'lead') pencils too, so you'll need an eraser to remove this.

You will also need a poseable blank maquette or figurine, available at any art store. Not sure how to draw someone running, jumping, sitting or from above or below?
Set up your figurine in the desired pose and copy it from any angle.

You will also need a brush. You'll get the best lines with brush and ink – from thick and thin lines to elegant and versatile strokes. You can also use brush pens, available from art stores. Use either of these tools to create hair, folds in clothes and so on.

You will need:

1. Paper – For now, scrap paper will do, preferably white cartridge. A sketchbook might be your best option, so that you don't lose any loose-leaf pieces of your favourite artwork! Layout paper, Bristol board and other types of paper are discussed later in the book. You will also be able to work directly on certain pages within the projects book.

2. Ruler – including inches (imperial) and/or millimeters (metric).

3. Masking tape – this is relatively cheap and available from any hardware store. It is better than clear adhesive tape, which may rip your paper.

4. Technical pens – such as rapidograph or isograph of varying sizes.

5. Technical pencils or push pencils – to use for fine detail.

6. Tone – used for mechanical, rub-down or computer effects. (See pages 96–99.)

7. Hands – all the better to draw with.

8. A brain – useful for ideas.

9. Time – to spare; more valuable than you might think!

10. A computer and graphics editing software such as Photoshop – If you want to take any projects that bit further.

ORGANISING YOUR WORK SPACE

You will spend countless hours drawing Manga. Lying on your bed or balancing a pad on your knee just won't do. Get comfortable and have everything at hand. One thing there's never enough of is... space!

Reference library – clip art, cool comics, books about your story's subject. Searching the Web is also very useful.

Glasses – if you need them. Have your eyes checked by an optician. Drawing Manga, like any detailed work, can wear them out.

Good bright light or a spotlight. Position it opposite the hand you draw with so you can see what you are doing.

Elbow room – there's nothing more annoying than having to keep brushing things out of the way while you are working. Make sure your work area is clear.

Sensible chair – to support your back. A bad working posture means aches and pains and is asking for trouble in later life.

Materials – readily at hand. Place them in an organiser of some sort, or on a small side table or cart (dentists have them – surgeons too – why not you?).

A PROFESSIONAL DRAWING BOARD MAY BE BEYOND YOUR BUDGET FOR NOW. AS A CHEAP ALTERNATIVE, ANY LARGE, CLEAN AND STURDY PIECE OF BOARD WILL SUFFICE. SAND THE EDGES TO PREVENT SPLINTERS. RAISE THE BOARD AT THE END FURTHEST FROM YOU BY RESTING IT ON A PILE OF BOOKS.

A professional drawing board has a parallel motion, which is adjustable to fit the user. It's also good for measuring accurate page dimensions. You should tilt your drawing board to a 45° angle. Drawing on a flat surface fools the eye. You can hunch over, but it'll kill your back.

What you think you are drawing. Hold it up.

What you have drawn. The bigger the drawing, the greater the risk.

CHAPTER 2

MANGA STYLES

FIND OUT ABOUT THE
CHARACTERISTICS OF
DIFFERENT KINDS OF
MANGA – WHAT MAKES
THEM SPECIAL AND HOW
YOU CAN DRAW THEM.

DRAWING STYLES

You can have *bishōjo* ('pretty girl') comics such as *Oh My Goddess!* in which a lonely student meets his very own fantasy woman. Prefer something a bit more realistic? How about a cold-war military thriller on an Imperial nuclear submarine? Too serious? Funny animal laughs come courtesy of a full-colour insert (in a black-and-white Manga magazine) featuring a family of hippos. Or how about a full-on sword and sorcery action epic? The story of how the world ends and is reborn, according to Buddhist cosmology. In actual fact, Manga come in a great many styles. Although a consistent look should be maintained within any single strip, pretty much anything goes in the world of drawing Manga.

Aa! Megamisama *Oh My Goddess!*
Chinmoku-no-Kantai *The Silent Service*
Nonbiri Monogatari *Carefree Tales*
Kumo ni Noru *Clouds of the Deva King*

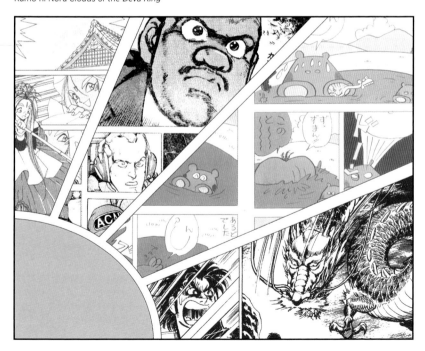

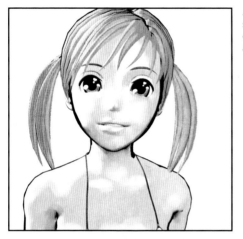

A *Chibi* anime character – small and cute. This one is drawn in a realistic style and outlined in black ink.

Another *chibi* anime character, rendered in a cartoony style.

FEATURES AND QUIRKS

What makes Japanese comics – and comics influenced by their style – unique? These are certainly not the comics your parents grew up reading, although they do share many fundamental qualities. First, though, let's take a quick look at the differences. We'll explore how you can achieve the techniques behind the style on later pages.

Manga art performs a daring and mismatched balancing act of the cute and frantic – an exciting mix of extremes – and it's not meant to be a smooth blend. Absolutely everything in Manga is made to feel like it's bursting forth from the page. Japanese readers respond to big faces, bigger expressions and larger-than-life emotions. Even subtle moods that are not so easily defined are expressed to the core.

The romance must be ultra-romantic, the violence ultra-violent, the sweetness a total sugar rush – from the extra-ordinary, to the super-human and completely over the top. Manga creators are often exploring and testing their own boundaries as to what is culturally acceptable. In that sense, Manga is one of the most accurate reflections of Japan's national identity and character. Just as the Manga you create will be a reflection of your identity and character.

This cutting-edge and challenging sense of style has put Manga among Japan's greatest and most influential cultural exports, and is itself a major part of the growing appeal of Manga around the world.

ONE-COLOUR PRINTING

For economic reasons (it's cheaper to print on pulpy, thin paper in bulk), the artwork for most Japanese comics is traditionally in black and white. Likewise, large areas of solid black are unusual because the paper cannot take it. That's not to say Manga are necessarily printed without colour. In one-colour printing, the ink doesn't have to be black, nor does the colour of the paper necessarily have to be white! If you have ever seen authentic Japanese Manga magazines, you may have noticed all sorts of variations.

The only time you will see Manga artwork printed in full colour, apart from the covers, is when it is adapted from the original production cels of an anime ('animation' film) or as a special insert. The first few pages at the start of any collection of popular serial strips are often presented in colour, with the rest of the artwork reverting to black and white. With advances in print technology bringing down the costs of colour printing, this tradition may change.

TONES

Without colour in their artwork, Japanese Manga artists instead make versatile use of tone. Tone enhances the mood of a scene with abstract or decorative effects, or else helps define shape, suggest a light source or add realism. It may take the form of fine linework, crosshatching, mechanical tone (dot screens), wash (grey tones made with diluted black ink) or any number of these. Keep an eye out for the use of tone in all examples of Manga.

Left: Black-and-white outline without tone.

Right: The same image, but with tone.

> **FOR A DISCUSSION OF THE TECHNIQUES USED TO APPLY TONE TO YOUR ARTWORK, SEE PAGES 96–99.**
>
> **FOR A BRIEF DISCUSSION OF FULL-COLOUR TECHNIQUES, SEE PAGES 100–103.**

SPEEDLINES

There are lots and lots of lines in Manga. This is why you'll need to have a ruler handy! Manga uses various line techniques to enhance all sorts of sequences. They are used to signify motion, emotion, action and dramatic mood shifts. Even fairly calm-looking images may suddenly sprout dramatic speedlines.

A related technique is 'motion blur' – when the edges of any object, or even entire objects, lose their definition and appear to blur (become less distinct from their surroundings).

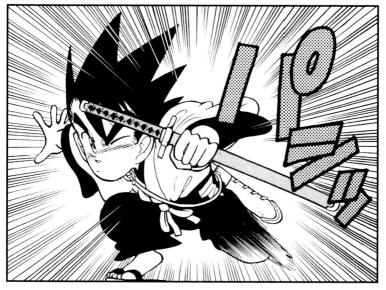

YAIBA, also known as *Legend of the Swordmaster Yaiba*

FORESHORTENING

Foreshortening is the 3D effect that makes flat, 2D images (ink on paper) seem to leap out from the page or appear like they are vanishing into the distance.

Comics of all kinds derive much of their dramatic power from the illusions created by foreshortening. If not drawn accurately, it may look as if a character has one limb shorter than the other, but, if the drawing is a good one, our minds interpret the image the way it was intended.

Manga styles in particular take foreshortening to even greater lengths.

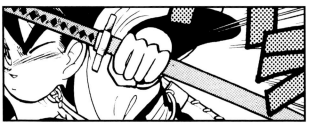

FOR SPEEDLINES AND FORESHORTENING, SEE PAGES 86 AND 92.

FOR A FEATURETTE ON THE MORE BIZARRE STYLISTIC FEATURES OF MANGA, SEE PAGES 94–95.

CLOSE-UPS

Comics have some techniques in common with movies, including a variety of points of view – the different angles from which a character is seen. Manga in particular favours multiple points of view during action sequences, but for dramatic moods nothing beats a close-up of the main character's face. Nothing, that is, except an 'ultra close-up' – when you feel like you are about to be sucked up into a nostril – so close you can count the hairs. Or when the bulge of an eye is so in-your-face the veins look like the branches of a tree. This is what you call an ultra close-up. Are you ready?

WINDOWS TO THE SOUL

Even without close-ups, many (but not all) Manga characters seem to have huge eyes. The eyes are said to be the windows to the soul, and because the Japanese are obsessed with mood and emotion, readers like to look right in there. The more they see, the greater the empathy they experience for the character.

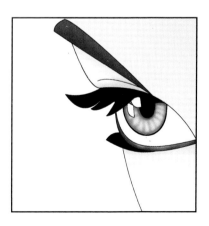

The look is often deceptive to Western readers. Characters that appear to be little kids may in fact be fully-grown adults. They may look cute, but their actions or words are anything but! This misunderstanding of Manga has caused some problems with censorship in the West, where comics are largely perceived to be for kids, and all cute Manga characters with huge eyes are perceived as kids.

Furasshu *Flash* 'Tough guy Wild West action'

YAIBA, also known as Legend of the Swordmaster Yaiba

Put all of the aforementioned features and quirks together and you get an action-packed page of Manga...

CHAPTER 3

MANGA CHARACTERS

MANGA CHARACTERS COME IN ALL SHAPES AND SIZES. THE ONLY LIMIT IS THE IMAGINATION OF THE ARTIST. HERE ARE SOME IDEAS TO GET YOU THINKING ABOUT YOUR OWN CHARACTERS, PLUS TECHNIQUES TO HELP YOU REALISE THEM.

CREATING CHARACTERS

We're going to begin perfecting your Manga technique by concentrating on the creation of your characters – how to get them out of your head and onto the page, and the many ways in which you can design them.

At first, it's always best to doodle and sketch – see where your thinking is and hash out some ideas. Work in pencil at this stage, so you can erase and amend the drawing as needed. After a bit of practise, or as your designs take on a more definite shape, you can use whatever drawing tool you are most comfortable with. But for now, when first drawing up a character that has yet to be properly worked out, pencil is best.

Pick your lead pencils carefully – nothing too soft (B series tend to be greasy) or too hard (H series draw too light) – HB should be just about right. There are also technical pencils or 'push pencils', refillable with lead filaments (also available in blue). These are good for fine linework, especially with tightly detailed Manga styles. Try one out in the store, and if it suits you, buy it. Don't forget to get some leads for it.

A question that design students often ask is 'How do you make your characters recognisable from one panel to the next, page after page?' The simple answer is to construct them very carefully – not only when first designing the way they look, but each and every time you draw them.

The proportions of the face (distance between facial features), the size of the head relative to the body, and the body shape must remain consistent. Then if a character's body contorts or transmogrifies (changes shape or form, as many Manga characters do), it is immediately noticeable and far more dramatic and effective.

TIP: Drawing from life will come in very useful for understanding bodily proportions and how they relate to movement. Study the human form, sketch from it, and return to these studies whenever you get stuck.

It may sound boring to have to draw the same character the same way, time and again. It isn't. In it's own way, the procedure is very satisfying – and makes for good Manga cartoons.

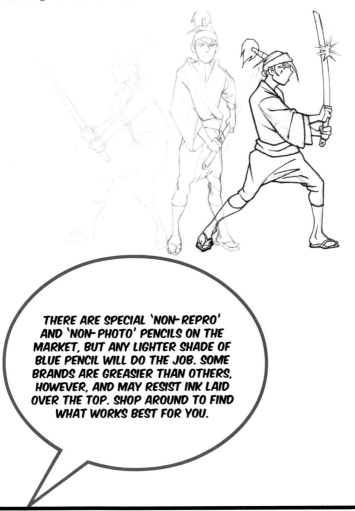

THERE ARE SPECIAL 'NON-REPRO' AND 'NON-PHOTO' PENCILS ON THE MARKET, BUT ANY LIGHTER SHADE OF BLUE PENCIL WILL DO THE JOB. SOME BRANDS ARE GREASIER THAN OTHERS, HOWEVER, AND MAY RESIST INK LAID OVER THE TOP. SHOP AROUND TO FIND WHAT WORKS BEST FOR YOU.

THE HUMAN HEAD

To begin, we should look at the basic construction of the face and figure. Your own style and character may be quite different and may not even be human. The steps below are general guiding principles you can adapt to fit your character, but only once you have mastered the basics.

One step at a time. Copy and draw the shapes below, but do not characterise them. Keep the drawings. There will be an opportunity to develop these further in later exercises.

Step 1: First you need a basic blank head, ready for drawing onto. Start with a simple oval.

Step 2: Divide the shape in half vertically.

Step 3: Then divide it in half horizontally.

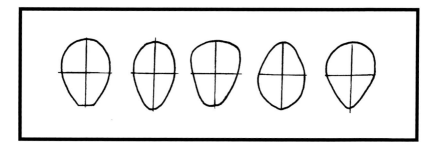

 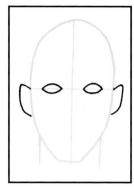

Step 5: Then draw the ears so that they hang from either end of the horizontal line.

Step 4: On the horizontal line, draw a pair of eyes.

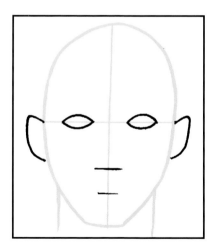

KEEP IN MIND THAT THESE ARE 'HEROIC' PROPORTIONS. NOT EVERYONE IS PERFECT! YOU CAN CREATE DIFFERENT CHARACTERS BY CHANGING DISTANCES BETWEEN FACIAL FEATURES AND/OR THE SIZE OF THEM, BUT IT'S BEST TO MASTER THIS BASIC FACE FIRST.

Step 6: Halfway down the lower half of the face, draw the nose, and halfway down the remaining space, a mouth.

THE HEAD FROM DIFFERENT ANGLES

By using a basic structure for the head, you should then be able to draw your characters from any angle. Of course, these are only lines on paper. What you are doing is fooling the reader into believing they are viewing a 3D shape turning in space, when in actual fact everything is flat. Your comic will be brought to life if your characters are constructed with their own sense of reality. This should not be mistaken for realism. Practise drawing the different angles illustrated below.

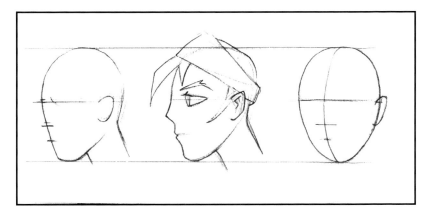

A view from either side of the head, side on, is called a profile. A profile should be recognisable as the same person you saw from the front. When you draw a character's profile for the first time, you will have to decide on such details as the size of the nose, the shape of the jawline, and so on. Try to keep these consistent with all other views. The vertical line shifts to either the left or right for a three-quarter turn. In the illustration above right we can see more of the left side of the head.

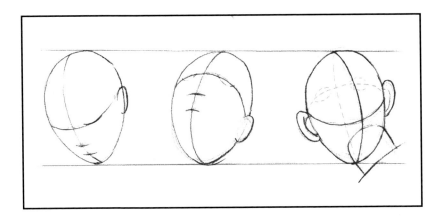

Viewed from above, sometimes called a down-shot, we see more of the crown, or top of the head. The horizontal line that divides the head into halves shifts downwards. This is also where you place the eyes.

Viewed from below, sometimes called an up-shot, we see more of the jaw and less of the crown. The horizontal line (or eye-line) shifts upwards.

Even when a character's back is turned, it's worth constructing the head with equal care. The position of the ears will often give away the 'hidden' angle. This helps the reader to interpret which direction the head is facing.

BODILY PROPORTIONS

The average human stands about six times the height of his or her head (see page 38). In this simplified form, the body has been divided into sections, a lot like an insect. In actual fact the human body is immensely complex – the hands alone contain as many bones as the rest of the body (that's one reason they are so tough to draw). Luckily, you have one right next to your pencilling hand to study and copy. Only by breaking down and simplifying body parts can we begin to understand the underlying construction – the skeleton beneath the skin – and how it operates.

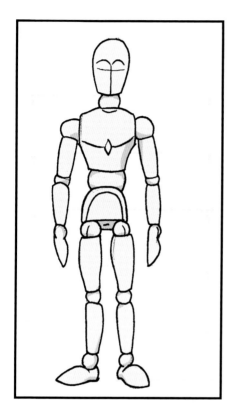

According to *How to Draw Comics the Marvel Way*, an excellent and useful guide to many basic comic-book techniques, American superheroes have a more heroic set of proportions: eight heads high. But then they also dress with their underwear on the outside and can't fold their arms. Such exaggerations come in very useful in Manga too, especially when it comes to character transformations. (*Dragon Ball Z* being a perfect example.) There are other changes to normal bodily proportions unique to certain forms of Manga. These will be explored further on the following pages.

As with most objects, the human body can be reduced to basic geometry – the limbs as divided columns of different thicknesses; the joints (sometimes called 'ball and socket') round, like a globe; the head another rounded shape, more like an egg, or squared off like a cube.

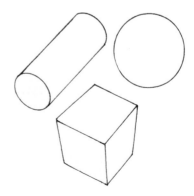

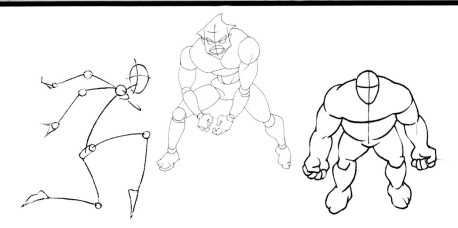

Use these as guidelines to draw the basic structure of the body, but not necessarily the form. Your characters, or those they meet, may not even be human, so experiment away.

As with the head, master the basic shape and structure first. You will find it easier to develop the different body shapes if you understand the underlying structure of the 'average' body. Study normal proportions before adapting or distorting them.

As you develop the form of your own characters, they will begin to take on their own dimensions. Their proportions - the distances between features, for example – may change. To appear convincing, your characters' movements should conform to their constructed physical shape. Then, whatever they look like, the reader will accept their essential reality and follow their actions without question.

This character design is of a demon whose humanoid body is based upon the proportions of a hyena. The upper body has been bulked up and the lower minimised. The forearms are longer than the upper arms (they would normally be about the same). This means the body as a whole has a new centre of balance and moves in a different way.

'TYPICAL' MANGA STYLE

Authentic Japanese Manga encompasses all the styles of illustration you can think of and many more besides – a universe of uniquely different characters.

In the West, to date, we have favoured a particular type of Manga. We have certain preconceptions about what defines 'typical' Manga style. Many people would like to know how to draw in these specific styles, and so – as well as showing examples of the many different Manga there are – we will concentrate on these more popular looks as a way into exploring the broader possibilities.

SYMPATHETIC CHARACTERS

In Japanese culture one of the primary elements of language is the communication of feeling – the transmission of mood. This is equally true of Japanese Manga. To better convey emotion, images are combined together, and accompanying words are crafted to enhance the impact of the images.

Manga characters are deliberately drawn in a way that maximises both recognition and the viewer's emotional response. Facial features are often constructed according to a fairly fixed formula, such as those seen in the examples right and opposite. All eyes and mouth, but little or no nose; simple, expressive and easy to repeat throughout the many panels of a comic strip.

Examples of what we in the West might consider 'typical' Manga style.

ONCE IN A LIFETIME

What makes us respond to characters that look like this? Think about it. Adults do not have any such exaggerated features, but almost every animal, human or otherwise, comes close to such an appearance at one time in their lives – as babies. Our perception of aliens conforms to this same stereotype – E.T., the SCHWA graphic, 'greys' (aliens). Some devotional paintings of Hindu gods feature what appear to be supernaturally intelligent children. Beliefs aside, the appeal of all of these images is essentially similar.

The characteristic rounded head and large eyes of a baby.

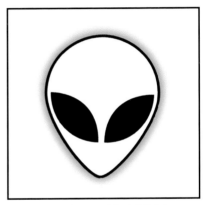

The SCHWA alien graphic. SCHWA is the underground conceptual artwork of Bill Barker. He draws simple black and white figures and alien ships. The aliens are metaphors for unknown and foreign ideas.

BIG HEAD

Try it out for yourself. Draw a wide brow or forehead. Make the eyes larger and draw them below the halfway line to concentrate the facial features in the lower half of the head. You might also want to angle the eyes differently, or space them wider apart so they are almost on opposite sides of the head, like a fish. Move the ears around. There is no fixed rule. Don't go into intricate detail just yet. At the moment, we are only exploring basic shapes. Concentrate on construction. Keep it simple. Explore all the possibilities.

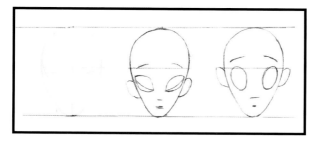

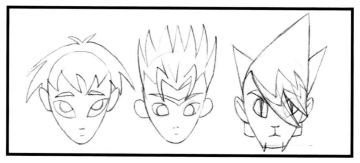

BIG HAIR

Hairstyle plays a big part in typical Manga design – spiky, shiny, feather-cut, fringes – so wild, it's almost alive. Spend an hour or two sketching, and see how many different styles you can come up with. Create the most bizarre hair you can imagine. The Japanese tend to have straight black hair, and consequently, so do many of their characters. There is no real reason why your own characters should. Be original. Defy reality. Go wild!

BIG EYES

With the eyes being that much bigger, there is ample opportunity to make a feature of the play of light across the pupil (the black centre) and iris (the surrounding coloured area). This makes the eyes intensely expressive. Use the techniques below to create a range of effects.

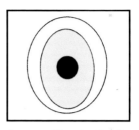

An eye without reflection...

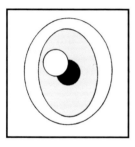

...a circle or disc of white, on top...

...or cut out of the other shapes...

...you can have light shining from one direction...

...two or more directions...

...an 'echo' of light deeper inside the pupil...

...or shimmering so bright it almost fills the eye...

CHIBI (OR NOT CHIBI?)

Here are some further variants of Manga that belong to their own style of basic character design. The characters below are designed by talented Manga artist Wing Yun Man – Trudy and Kurokumo or 'Black Cloud'.

They may appear to be about the same age, but Trudy looks that way because she is aged about 10, while Kurokumo is actually closer to 21. Here, however, he has been drawn *chibi*-style.

> CHIBI, OR 'SUPER DEFORMED' ('SD'). SHRUNK INTO A SMALLER, CUTER FORM WITH A LITTLE BODY, A LARGE HEAD, PLUS EXAGGERATED FACIAL EXPRESSIONS AND MOVEMENT.

BEING CUTE

Chibi characters have heads as big or bigger than their bodies. It is as if childlike proportions have been applied not just to the head, but to the whole body. Undeniably cute. A *chibi* appearance does not necessarily mean a character always looks this way. It may be one aspect a character takes on, in the same way an actor would wear a mask, for a panel or scene where they are being cute or humorous. See page 217 to learn how to create your own

chibi portrait. The influence of *chibi* styling may be seen in some Western comics and animation. The most popular Manga characters are merchandised in *chibi* form, as key rings, etc.

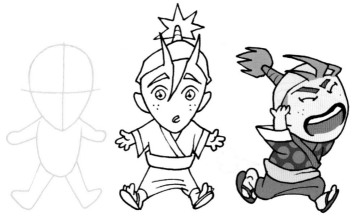

MASCOTS

One stage further away from humankind are these cute and funny creatures – a staple ingredient of Manga and Japanese character merchandise. The most well known example is Pokémon. Mascot design is all about simplicity – these characters have minimal features and strong shapes. Below are some mascots, two of which you will meet later on in the book.

BunQ For no sane reason, an elephant/ rabbit/maggot cross.

Kittylips Buff lady robot, like a walking, talking lipstick.

Hissy A blue cat with a bad attitude.

CLASSIC MASCOT ART
by Maguro LiLi

This step-by-step will take you through the process of creating a robot mascot character that relies on simplicity and strong use of shapes.

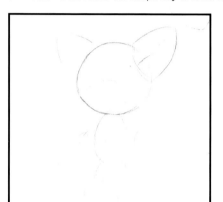

Step 2: After you are done with the head sketch, move onto shaping your robot. Place two rough circles on the head for eyes. You can link almost any part of the body with cylinders; just play around and see what you get.

Step 1: Creating a robot is not as complicated as you think it is as long as you start with a basic line. Here, we will draw a simple cat robot with basic shapes. First, create a big circle as a head. (Or use any shapes you want to build your own robot.)

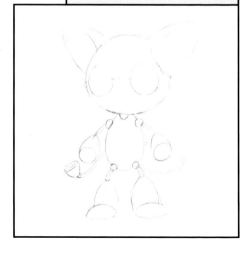

Step 3: We have the shape, now it's time to add the details. This robot is a *mecha*, and contains a multitude of components. Just have fun and create robotic components according to your own creativity. For this robot, I left it as simple as possible to retain the concept of cuteness.

Step 4: Always shade your character with a base tone first before going for the darker tone. Set the lighting direction of your choice. You can always use a real object as a reference.

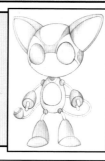

Step 5: Shading a round object is no problem when you have a reference. But remember, a robot is made from metal, which is a glossy material. When it is glossy, no matter how dark the object is, as long as there's a little bit of light there will always be a reflection. Pay attention to the curve of the ball highlighted here; there's a reflection of light which may be from a wall, the ground or any object nearby.

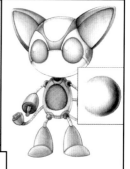

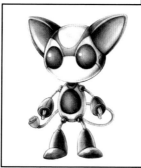

CHAPTER 4

MANGA GENRES

MANGA CAN BE ABOUT ANYTHING AT ALL, BUT THERE ARE ALSO DISTINCT GENRES WORTH EXPLORING; USE THEM TO INSPIRE YOUR OWN CREATIONS.

MANGA GENRES

Spreading like wildfire, first in the East and now the West, an appreciation for the wider world of Manga has begun to catch on. The popularity of Manga is exploding. This is the 'Manga revolution'. More than style, Manga have wide and fashionable appeal largely due to the diversity of their subject matter – serial comics about everything under the (rising) sun.

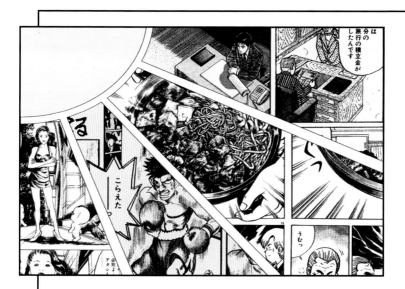

Romance or pretty-girl (and pretty-boy)

There are not only stacks of *bishōjo*, 'beautiful girl' or 'sexy girl' titles being printed, but also *shonen ai*, highly stylised 'boys' love' comics – exactly what they sound like, and very popular among girl readers.

Sports
From the more obvious – baseball, boxing, sumo wrestling – to a
whole slew of titles based on board games, such as mah-jongg
(mah-jongg cowboys, strip mah-jongg, murder-mystery mah-
jongg) and pinball (*pachinko*).

Salaryman
They may sound like boring business to us, but these comics – full
of office politics, intrigue over promotions, mergers and
acquisitions, and so on – are a mainstay among adult male readers.

Cooking *Daddy the Cook*, just one of many long-running series –
a soap opera based around different basic life skills with social
commentary. Every episode features a recipe and a large food
'money shot'!

SHONEN AND SHOJO

When you come to draw your own Manga, who and what will it be about? In the pages that follow we begin to explore just a few of the many possibilities. 'Typical' Manga (typical only insofar as it's the kind we most readily understand, and import) can pretty much be divided into two major types – *shonen* and *shojo*.

SHONEN

Shonen titles are targeted at juvenile males. They are principally adventure comics, including sports and fantasy action. *Shonen* means 'boys'. When the boxer Ashita No Joe ('Rocky Joe'), a survivor of many matches, died in the ring, it seemed like the entire country turned out in mourning. Very few comic characters can claim to have reached that level of recognition. If you thought that boxing was too brutal, it's no more dangerous than ping pong, martial arts, tennis, soccer, baseball or any other sport when it's played to the extreme, Manga-style.

THE NAME OF THE GAME IS ACTION – ACTION, ACTION, AND THEN, FOR GOOD MEASURE, MORE ACTION! LOUD! BIG! IN-YOUR-FACE!

Shonen Jump is home to the phenomenon *Yu-Gi-Oh!*, and was a showcase for the infamous *Dragon Ball* before that. It's one of the few translated titles on Western newsstands to be marketed in the original *zasshi* format.

SHOJO

Shojo ('girls') strips feature more of the same, immediately recognisable 'big eye' styling as *shonen* Manga, but with a different focus. The popular genres in *shojo* include romance, school, magic, costume drama and comedy. They are primarily mood pieces that centre on the expression and suppression of emotion. When a character attempts to hide his/her feelings they are often expressed in other telltale ways. As a result, *shojo* are full of symbolism – otherwise inanimate objects taking on special significance, as symbols or metaphors for something other than what they actually are. Falling leaves, breath on glass, the ticking of a clock or even the weather are all methods used by artists to give a scene a particular mood.

Most of the Manga currently being published in the United States by companies such as CMX (DC Comics) and Tokyopop are translations of *shojo*. It's important to remember that this is only one kind of Manga, which comes in many forms.

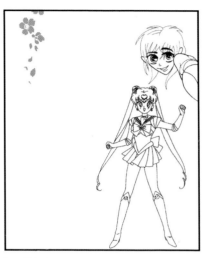

Possibly the most popular *shojo* in Japan – *Bishoujo Senshi Sailor Moon*.

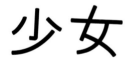

*KANJI**
'SHO' AND 'JO'
SHO = 'LITTLE'
JO = 'WOMAN'
SHOJO = LITTLE WOMAN, OR 'GIRL'; COMICS FOR GIRLS.

WANT TO KNOW MORE ABOUT KANJI CHARACTERS, AND HAVE A GO AT WRITING SOME? SEE PAGE 143.

MECHA AND MONSTERS

Science Fiction is another popular genre within Manga – the near-future fiction of *Akira*, set in a post-apocalyptic Tokyo, is a prime example. However, the most common form is *mecha*, or robot genre, such as *Patlabor: Mobile Police* and *Gundam*, or strips that prominently feature robot characters, such as *Appleseed* and *Full Metal Alchemist*.

Robots come in all shapes and sizes. Sometimes they can be menacing, but far more often they are forces for the service of good, imbued with all sorts of worthy human virtues – patience, strength and loyalty. The Japanese seem to have a peculiar fondness for their robots, which may explain why they are at the forefront of the development of real working robots – as household servants, guards, companions and even pet dogs... An example of science fiction becoming fact.

Kaiju means 'monster', another popular genre, which includes Manga creature features such as *Gojira* (Godzilla) and company. When a monster meets a giant robot (Mechagodzilla, for example) watch out! You are almost certain to get trodden on. Alien life forms also come under this general banner.

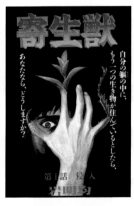

One of the more unusual strips to be translated in recent years is *Unwilling Host* (*Parasyte* in the US), in which an alien bonds with the body of a young man to form a 'symbiote', or joint consciousness and shared biology.

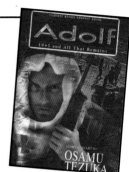

OTHER GENRES

Moving onto some of the more adult titles available, the range of genres and the styles in which they are drawn really begins to proliferate. Here are just a few of the most popular:

• Prores (short for 'Professional Catch Wrestler') is a genre about pro wrestling! An equivalent to WCW (World Championship Wrestling) and WWF (World Wrestling Federation) – with even wilder costumes and combat moves.

• *Seinenshi* are 'young men's magazines', aimed at adult males in their twenties and thirties.

• There are also satire and parody Manga (think *MAD* magazine with an added twist).

• Hard-boiled detective fiction or gumshoe is also popular. Then there are the gangland stories – tales of schoolyard wars and the more sinister Yakuza (Mafia) variety.

• Horror, magic, funny animals and legends are also on the reading list.

• Manga also explore nonfiction and fact-based fiction. History lessons come alive in these series. The *kanji Shi Ki* stands for 'History presented through a series of biographies'. Osamu Tezuka (see page 6) created more than one biographical saga – not only tales of Buddha (*Budda* in 14 volumes), but also the triumvirate *Adolf*.

Top: *Adolf*
Middle: Italian translation of *Life of Buddha* from Hazard Edizioni
Bottom: *Lone Wolf and Cub*, by Kazuo Koike and Goseki Kojima, is one of the foremost examples of *chambara*, or 'fencing' stories.

CLASSIC SHOJO ART
by Bram Lee Chin Horng

A popular form of Manga is *shojo*, which is predominately created by women for girls and women. I have created a classic *shojo* character, paying special attention to the use of colour.

Step 1: I sketched out the anatomy of the character and design the pose that will best depict her personality.

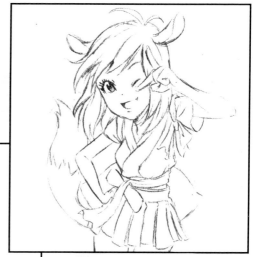

Step 2: Next I drew a pencil outline of the character. Make it as neat as possible to avoid any confusion during the inking stage.

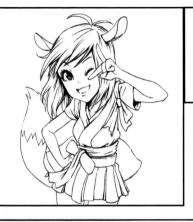

Step 3: I inked the character according to the pencil outline.

Step 4: I put in flat basic colours for the character, being careful about complementary colour combinations in order to achieve a harmonious result.

Step 5: I started to add some shading to the character.

Step 6: I added highlights to bring out the shapes as well as to make the rendering richer and more interesting.

Step 7: I used a simple background with only a few colours in order to retain emphasis on the character.

Step 8: In Photoshop I used the Airbrush tool to enhance the overall mood and lighting.

CHAPTER 5

STORYTELLING

MORE EVEN THAN THE CHARACTERS, GENRE OR DRAWING STYLE, IT IS THE STORYTELLING METHOD THAT MARKS MANGA OUT AS SOMETHING DISTINCT AND DIFFERENT. HERE'S A CLOSER LOOK AT HOW THE ACTION SHOULD UNFOLD.

STORYTELLING

It is the substance of the story that is truly important, not the surface appearance – although the appearance will always be the first thing that anyone notices. Hopefully by now you will have some idea of the wide range of styles, characters and genres found in authentic Japanese Manga. You may want to use some of these as inspiration for your own storylines.

A comic strip may best be defined as 'words and images, or just images, combined in a sequence' – usually with the aim of telling a story. However, it's important to remember that a narrative isn't always linear (beginning, middle and end), and a comic strip, as with any art, may take on a more abstract form. This is particularly true of Manga, where a sense of mood is as important as conveying a sequence of events – something worth keeping in mind.

Sazan Aizu, 3x3 Eyes

To Western eyes, some Manga pages may seem almost abstract – but there is usually a definite purpose behind the layout and imagery. Page design governs the flow and pace of an action sequence, or creates a mood. See page 183 for how to read this sequence.

A CLOSER LOOK AT A MANGA PAGE

Before going any further we should take a moment to explain the various comic book terms we will be using, and at the same time look at their specific application to Manga.

• Page (1) – a single unit, usually only part of a longer sequence or story. Two pages together form a spread. The area toward each page edge is known as the margin. In this particular example, the panels 'go to bleed', extending off the edge of the page.

• This page is divided into panels (2) – there are six panels on this page.

• Layout – the arrangement of panels on a page, as well as the arrangement of various elements within each individual panel. In this layout the first panel dominates, and the other panels overlap, as lesser 'moments' around the main event. In effect, the main panel carries on behind the others (indicated by the dotted line, 3). Smaller panels are 'inset'.

1

Panels laid out side by side in a horizontal row form a tier. Manga layouts are more fluid and fragmented than other comic book styles.

4

In a complicated and fragmented page such as this it is hard to say how many tiers there are – perhaps two, perhaps five.

2

SPEECH BUBBLE

SOUND EFFECT

5

6

CAPTION

3

Any lettering (or 'text') on a comic page usually comes in one of three forms – speech balloon, sound effect or caption (5). Text captions are unusual in Manga. Readers of modern American comics may have noticed them being phased out in recent years due to the increasing influence of Manga and film. For the sake of clarity no actual imagery or lettering appears on this layout.

The gap in between both panels and tiers is the gutter (6). In American comics they tend to be of uniform size or width. In Manga, as well as in many European comics, vertical gutters between panels are often thinner than horizontal ones. This encourages correct reading order.

PAGE DESIGN

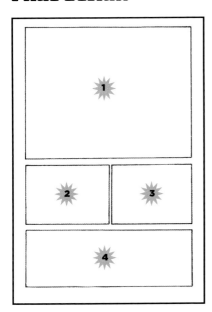

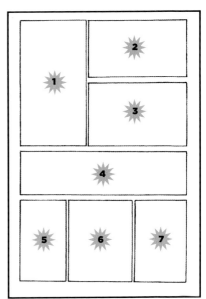

REGULAR LAYOUT

A comic book page with a regular layout has anything from two to four tiers, and within that an optimum three to seven panels (any more than that and the page begins to look crowded). The vast majority of Manga conform to the deceptive simplicity of a regular layout, such as these above, letting their images carry the story forwards.

IRREGULAR LAYOUT

Many modern Manga – and particularly those aimed at a younger readership, such as *shonen* and *shojo* – prefer no limits to be imposed on their expression of energy, and experiment with layout in all sorts of ways. Panels vary greatly in size and shape, run at angles to each other (sometimes even right angles) and often go to bleed (continuing right up to the margins of the page, filling it entirely). If this is a style you want to try – watch out! It is a lot harder to get it right without losing the sense of forwards motion, or the order in which the page needs to be read. As you experiment, make sure that the energy you want to create isn't lost in the complexity of the layout.

Consider what style of layout is most suitable for the kind of story you want to tell. A regular layout will not inhibit the amount of excitement you want to convey. This is as much down to the composition within the panels as it is the composition of panels on a page.

The layout of your page helps to convey an action, mood or emotion, and sometimes all three at once. Rather than obscure any message it should emphasise and enhance all that you want to portray. A simple and direct approach is best, unless that goes against the feelings you want to evoke.

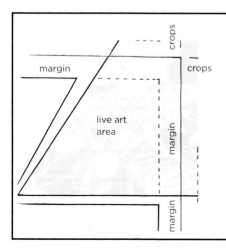

In this example the panel goes to bleed – both at the side and top. The area at the centre of the page within the margins, where the main part of the image resides, is called the 'live art area'. All lettering and any vital detail should always remain inside this area. When printed, the pages are cut (or 'cropped') to the final size and the crop does not always fall in the exact same place. Artwork for panels taken to bleed must always include at least 5 mm ($^1/_4$ inch) extra, just in case it doesn't get chopped off and you are left with blank areas around the edges.

FRACTURED MOMENTS

Story moments are often shown on pages divided up into a series of angular panels, like the shards on a pane of broken glass. This fractured look to the layouts of some (but by no means all) Manga is something immediately apparent about them. They are exciting to the eye, but this is not the only reason you should use them. Page layout should never be arbitrary; it should always serve the story. Work out what you want to feature in each panel, designing the page in the way that will gain the most impact. However, your layout should have an element of logic so that it is clear and easy to read.

Before you start to lay out your pages, you should work out your story with simple sketch drawings, jotting down notes for the dialogue as you go. These are called thumbnails. They are very rough sketches (as if etched with your thumbnail, and featuring panel layouts that aren't much bigger – a bit like the blank template examples shown to the right). You'll be hearing a lot more about these in later sections.

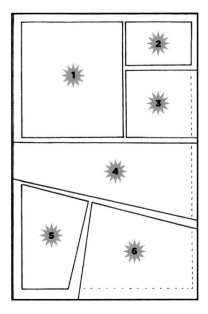

Layouts may change style mid-page according to story events. Here the page starts out 'regular', but then bursts out of alignment (even the gutters), becoming an irregular layout.

As you design your pages, think about which elements you need to show and what you can get away without showing. You should also consider what angle to use for each movement. Keep things minimal. Aim to include everything that is necessary, but equally, show nothing that is unnecessary. The eye should follow the story from panel to panel with ease. If there's an awkward break, you may need to add or subtract a panel to aid the flow of the storytelling.

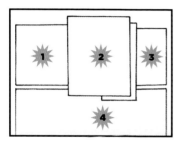

Inset panels work in all sorts of ways. Here they appear to overlap to the point of stacking up (the panel behind serves no function other than to emphasise panel 2). In Manga a small panel like number 3 is often filled with just dialogue or sound effects. This would be unusual in a Western comic.

This panel arrangement is almost a reverse of the top half of the seven-panel page layout opposite (and is where flipping original right-to-left Manga pages can go wrong). The different widths of horizontal and vertical gutters gives a subtle clue to the correct reading order, but this layout of portrait (upright) and landscape (lengthways) panels could confuse readers and is ill-advised. Try to avoid it.

POINTS OF VIEW

Every panel of every page contains a scene or point of view seen from a certain angle. In terms of angles ('shots' or 'camera angle' – movie phrases are widely used), a Manga artist has a whole range of possibilities. Experiment with different angles to arrive at the one that best suits your scene.

Vary the point of view (P.O.V.) from panel to panel. You can combine different angles in a variety of ways. Constantly changing the angle from which the action is seen makes for exciting storytelling, but choose carefully. Each shot has its own meaning within the context of your story, so make each choice for a reason. Every single shot is part of a sequence, and should be treated as such. It should work according to the panel in front and the panel behind, as well as the rhythm of the page. Make sure your storytelling flows. If you get carried away you'll lose the plot, and so will your readers. On this spread is a short scenario, played out in an exaggerated style in order to show a selection of the most basic variations of P.O.V. Every sequence of a comic strip has its own dramatic tension or mood, and the order of the shots is key to its creation.

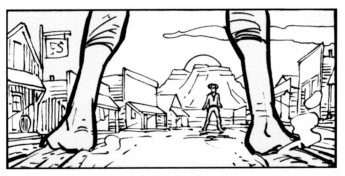

This is an establishing shot. Every time you change to a new scene you should include one of these. Are we outside or inside? Is it day or night? Early or late? What's the weather doing? Decide on the circumstances – they may affect how your scene plays out. Redefine these details each time you change to another scene. Establishing shots do not need to be uninteresting, and not everything has to be established right away. In the panel above we can tell there are two characters, but one is too close and the other too far away to see who they are just yet.

In this example, a high angle (or bird's-eye view) has been adopted. A long shadow dramatically links the two characters. They stand far apart. The only way a two-shot (one that includes them both) can be accomplished is to view either or both characters from far away.

Here, we take a much closer look at the shadow-caster. This low angle (or worm's-eye view) contrasts with the previous image, and includes a dramatic three-quarter view that shows his hand hovering close to his weapon. This adds tension to the scene, as the character prepares to draw his gun in anticipation of a shoot-out.

This shows a classic head and shoulders shot, from front on. As we saw in the previous panel, the other character is in shadow, which means this character faces the sun.

A close-up of the first character again, still from a low angle. Looking up into his face, in shadow, gives him an air of menace. It's as if he towers over the reader.

This is an extreme (or ultra) close-up. This is also a zoom-in from the head and shoulders shown at the top of the page.

Recovering distance in the scene again makes a dramatic contrast to the extreme close-up of the preceding panel.

ACTION SEQUENCE
by Irene Strychalski

I wanted to create a small, powerful action sequence, using close-ups and perspective to create maximum impact in a minimal amount of frames.

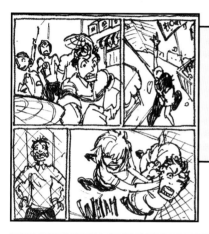

Step 1: I had a couple of ideas in mind for an action sequence, but I wanted to do something that could tell a story, so I settled on a policewoman chasing a crook through a busy market area.

Step 2: I thumbnailed the action sequence I had in mind. The thumbnail is probably the most important part of an action sequence; nothing has to look good yet, but it's important that the characters are all moving in the same direction through all the panels, and the environment is consistent.

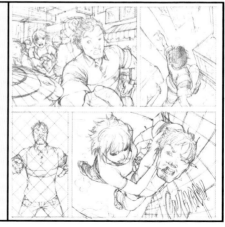

Step 3: I pencilled the sequence out with details. The sound effects are part of the composition, and notice I fixed the placement from the thumbnails.

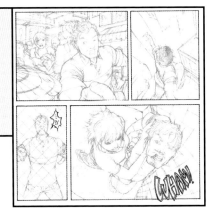

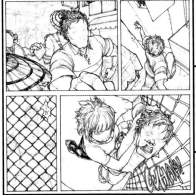

Step 4: I inked in the panel borders, speech bubbles, and sound effects first. For this I used 0.8 size Micron markers.

Step 5: Then I switched down to 0.3 Micron markers for the thicker interior lines.

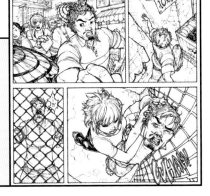

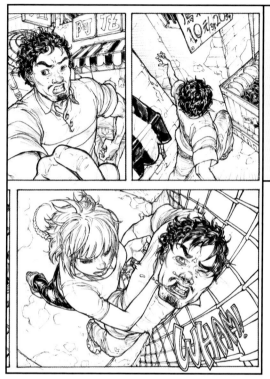

Step 6: Faces are more delicate and I used a size 0.05 marker for them. Also backgrounds should be drawn with a thinner line to help create depth.

Step 7: I spotted the biggest blacks like hair colour with a brush and India ink.

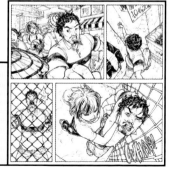

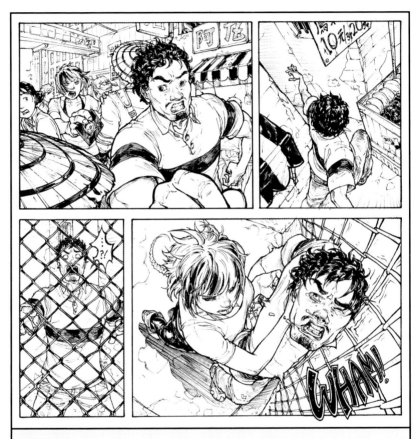

Step 8: Then I added in smaller parts that needed shading, I was just tweaking by this stage. I decided last minute to throw a shadow in the last panel to make it pop. I fixed up minor mistakes with white.

WHERE THE ACTION IS

Manga mood and Manga action sequences are often created as a total experience, not just a series of events in a strict order. Think of events as if seen from multiple camera angles – a composite, not just one thing after another as in the sequence you just looked at. The primary influence on this form of storytelling is cinematic, and in movie terms is known as a 'montage'. When used in concentrated bursts it either conveys fast action or telescopes a much longer sequence or series of sequences into a shorter screen-time, usually set to music (watching a character grow up in the space of a few minutes, for example).

You should not take multiple camera angles too far or readers will not be able to follow your story. Many action-movie directors (or editors) are not as good as they need to be at storytelling – if you cannot tell who is doing what to whom the drama has no real forwards motion. The action may be fast-moving, but it is like an eye bath – it never even reaches the brain. Good comics, like good movies, work like brainwashing. The reader experiences total immersion, and should never be placed in any doubt.

Take a look at the Manga example opposite. Although you cannot read the words, try reading the images (in the correct reading order.) Let your eye flick around the whole page at one time and you will get a better sense of it. Aim for 3 to 4 seconds. These pages are designed to be read fast.

TIP: Watch the gutter. The gutters in Manga do much more than separate and indicate individual panels. The comic creator may have carefully selected what to show and the angle to show it from, but it is in these gutter spaces in between images where the action really happens.

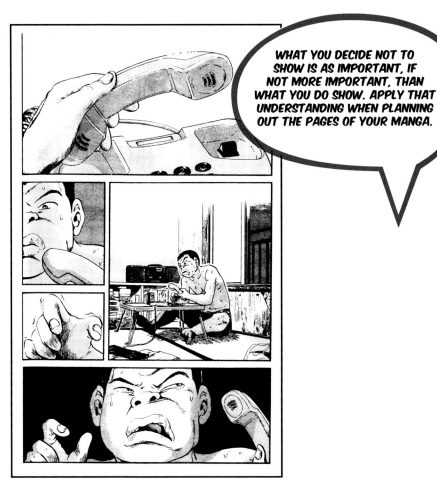

The character hesitates before dialing. In the West, we have fewer pages in which to tell our stories – thus, we tend to tell them in concentrated bursts, and to read them more slowly. In Japan, they can relate the same amount of information across a great many more pages, and generally design them to be read at a faster pace.

PACING

Manga artists aim to control the speed at which their pages are read, and they do this through pacing. Using the layout of panel and page, they play time like an accordion – compressing it for one sequence, extending or opening it out for another. It is always worth varying between a fast pace and a slow pace – without a measured pace in between we would have no sense of variable speed and thus no drama. Always playing fast can be as exhausting as always playing slow is boring. Do whatever is most appropriate to your story.

There are many ways to control pacing. The first is what actually happens in the images shown. A great extended sequence occurs in the epic *chambara* series *Lone Wolf and Cub*. Two samurai must face off against each other in a duel. They take up their positions and stand stock-still, through a day and a night. In the darkness of night only the burning of torches shows that they maintain their relative positions. That's right – pages and pages of nothing happening – but the build-up of tension is unbearable.

At dawn on the following day (see below), the reflection of the sunrise can be seen traced along a raised sword, showing the passage of time in keeping, perfectly, with the scenario. When the action finally does come, it is all over in a few panels and a few seconds, and made all the more exciting by the extreme contrast in pacing.

Argentinian comics *sensai* Oscar Zarate plays a tango theme on his *bandoneon* (or 'squeeze-box' – a small accordion especially popular in South America). In Japan, most Manga artists start out as an understudy to a *sensai* (or 'master').

In this sequence from *Lone Wolf and Cub*, the light of the rising sun moves up the blade of a raised sword. This tells us that some minutes are passing.

The amount of detail you put into a panel will also affect the pacing. With each panel you prepare to draw, ask yourself – is this a fast or a slow panel? An artist can deliberately slow the reader down or speed the reader up by varying the amount of detail they put into a panel – even by the speed at which it is drawn. The more detail in a shot (unless it is perfectly realised), the slower it is to read. The less detail, the quicker it is to read. The amount of lettering will also have an effect, but the pace is not only limited by this.

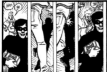

A shift in panel dimensions (size and shape) and a switch from light to dark create a sudden change of pace.

Sometimes a panel exists purely to speed the reader through events from one main panel to the next or, conversely, to create a pause. Panels between one or more separate scenes often serve these functions – they are called transitional panels. These may be used to indicate the passage of time. In *Barefoot Gen*, for example, the merciless glare of a hot sun is a repeated feature.

A rapid sequence can be achieved using narrow or small panels, or sometimes a series of panels of equal size and shape. Same-sized panels with little change in viewpoint deliver a steady pace. Slow progress may be achieved by large, wide panels – but, if there is little detail in them they may have the opposite effect. Extreme variations in size and shape and/or drastic shifts in viewpoint can be used to gain speed or slow things down, but constant change confuses and slows the reader. See for yourself how a sequence reads in a series of small sketches. Work out the individual panels first, then join them together into page units. If the number of pages is set, you may have to shuffle panels to fit everything in. When finalising the panel size, keep an eye on the level of detail, according to your original intent for pace.

GOOD COMPOSITION

Resist a natural urge to fill every panel of every page with action and detail. You may find this difficult at first, but you should learn to use the space. Blank space is sometimes called 'negative space', but it is filled with positive energy. Just because it is blank does not mean that it serves no purpose.

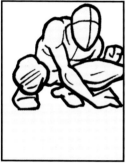

Think of a character crouching like a tiger about to strike. If you pen him in too close to the panel borders he has nowhere to go. With plenty of space above him the reader sees him rising, about to fill that waiting, empty space.

If a character's body language or speech implies movement, use the available space to supply it.

At other times, filling all of the available space may suit your dramatic purposes.

Going against the reading order arrests forward motion and is equally useful. Changing direction within a sequence is sometimes referred to as 'switch and turn'.

CONVEYING MOVEMENT

Good choreography makes for great action, and this is equally true of characters sitting around talking, as much as characters who are trying to knock each other's heads off. Good choreography involves a sense of knowing and showing who is where when you begin any sequence. The motion is supplied by an idea of where they are going when and if they move. This is confirmed and understood by an equal sense of where they have ended up at the end of the sequence.

In practise, this is not nearly as obvious as it may sound. Unless you are a complete natural it will take time, so be prepared to make plenty of mistakes before you learn what works.

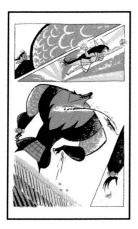
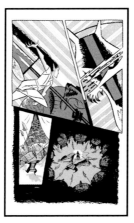

In this working example of Manga, the figure breaks out of the panel borders to extra effect. Like a one-two punch, the slashing action on the second page gains momentum through a switch in direction even though it now goes against the Western-style reading order. Abstract effects (like the lightning bolts) heighten the action. In Manga, sound effects often provide these electric shapes.

THE MANGA FIGHT SCENE
by Bram Lee Chin Horng

Manga art often relies on dramatic use of perspective and abstract-yet-cinematic camera angles. I wanted to create a fight scene using such techniques.

Step 1: A simple one-point perspective was used in this illustration. The sizes of the two characters varies to create more depth of field.

Step 2: I outlined the sketch using a mechanical pencil, picking out the details and designs of the characters.

Step 3: Debris and dust effects were added to bring more sense of movement to the illustration.

Step 4: The pencil outline was inked using waterproof black pen. Speedlines and motion blur were added in Photoshop for visual impact.

Step 5: I added some strong highlights and rimlights to enhance the mood of the illustration.

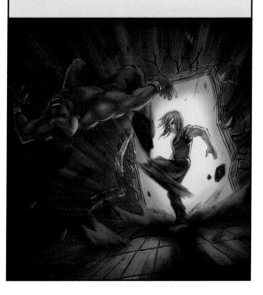

LETTERING

A first attempt at Manga is often let down by bad lettering, making it hard to follow. This can be due to legibility – lettering that is itself difficult to read – or bad placement (balloons that allow themselves to be read in the wrong order). Invite people to read your pages by taking the time to letter them correctly.

LETTERING SHOULD NOT BE UNDERESTIMATED IN ITS IMPORTANCE TO PAGE DESIGN, PACING, GOOD COMPOSITION OR READING ORDER.

CRUSHED LETTERING DOES NOT INVITE READERS. IF YOU DO NOT HAVE A CLEAN AND STEADY HAND-LETTERING STYLE THERE ARE MANY COMPUTER-GENERATED FONTS AVAILABLE. MAKE SURE YOU PLAN AHEAD AND LEAVE SPACE FOR IT IN YOUR PANEL LAYOUT.

CENTRE YOUR LETTERING WITHIN BALLOONS AND TRY TO LEAVE PLENTY OF WHITE SPACE AROUND IT. YOUR BALLOONS WILL USUALLY NEED TO BE BIGGER THAN YOU THINK.

PLANNING AHEAD

Letter your pages before you start to draw, even if it is only in pencil, so that you don't spend hours drawing details that may get covered over with dialogue. Careful planning will save you a great deal of time in the long run.

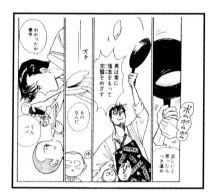

As well as reading from right to left, would you believe Manga balloons read vertically!? Take pity on the poor souls who have to re-letter translated Manga in order for you to read them! The re-orientation of balloons often creates gaps, and new artwork must be created to fill them. In this example from *Par-Peki-no-Chichi* ('Perfect Father') the layout flips over, like a pancake.

SOUND EFFECTS

Japanese pictogram lettering is perfect for sound effects. It's too bad we can't read it as anything more than abstract shapes. However, you may want to recreate the appearance of Japanese lettering styles when drawing your sound effects, or write them Western-style. Or, like in this panel, below, you can work out what the originals mean from the way you see them used and include some. The one to the right probably represents the whooshing sound of an object flying through the air. But, you'll have to accept that only you may understand what the sound symbolises.

CHAPTER 6

SPECIAL EFFECTS

FIND OUT HOW TO MAKE
SPEEDLINES, COLOUR,
TONE, TEXTURE AND
FORESHORTENING WORK
FOR YOUR MANGA
CREATIONS, BRINGING
THEM DYNAMICALLY
TO LIFE.

SPECIAL EFFECTS

From sound effects to special effects: As we have seen, Manga specialises in taking everything to extremes. Displaying the maximum speed, motion and emotion requires a number of special techniques. The best way to familiarise yourself with these various techniques is to study your favourite Manga. The examples in this chapter take you through some of the most basic techniques. As you practise, think about where and how you might use them.

HOW TO DRAW SPEEDLINES

There is no real secret to this. You need patience and a ruler, as well as lots of practise to gain a firm hand. Messy speedlines will only draw attention to themselves. When they are perfect they 'disappear' into the reading experience. Very few styles suit loose linework, notably that of the artist Kojima on *Lone Wolf and Cub*.

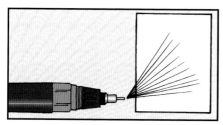

A technical pen gives the best line. Radiate from a single point (often situated somewhere outside your actual page area).

IF YOU FIND DRAWING SPEEDLINES DIFFICULT, DRAW AND KEEP A MASTER SET – SEPARATE FROM ANY IMAGE AND AT A LARGER SIZE, AND DROP IN A COPY WHERE YOU NEED IT. IDEALLY, YOU SHOULD LEARN HOW TO DO YOUR OWN SPECIFIC TO EACH IMAGE.

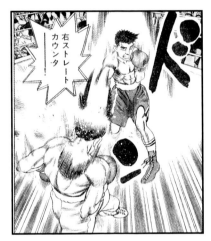

Draw the lines in the same direction each time, not backwards and forwards. Releasing pressure as you make a line (and moving your hand a bit faster) 'fades' it out towards the end of each stroke.

The direction and shape of your speedlines will affect the reader's interpretation of a scene. The curved, circular lines indicate the swinging of a bat.

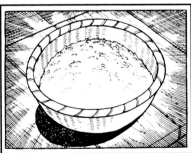

Speedlines are also used to signify certain emotional reactions, or to act as highlights that draw your attention to something. This is how a bowl of rice might look to you if you were hungry.

HOW TO MOTION BLUR

As the name implies, speedlines often surround an object or person to suggest they are moving at high speed. In Manga this effect is heightened when the edges of the thing in motion become indistinct – they either blur or disappear entirely.

MANGA ACTION
by Elli J Puukangas

Here I created a female action character using simple linework and a dynamic use of speedlines. Use the exercises on pages 34–39 and 150–155 to help you with your character design and body proportions.

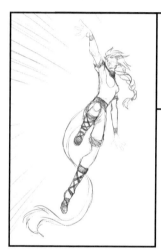

Step 1: I sketched the design with a blue pen or pencil.

Step 2: With a technical pen or pen and ink, I started drawing on top of the sketch.

Step 3: Speedlines are a little tricky. I've created multiple different versions of them to use with the appropriate image.

HOW TO FORESHORTEN

Almost everything, from cityscapes to the human body, can be simplified into basic building blocks. These blocks consist of simple geometric shapes, such as a globe (circular), cube (square) and column (cylindrical). A Manga artist uses these shapes to create his/her character, as well as the world they inhabit. This reinforces the illusion of three dimensions (space) existing within a flat, 2D drawing.

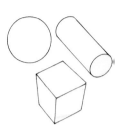

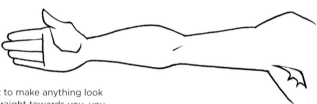

Step 1: If you want to make anything look as if it is coming straight towards you, you need to foreshorten it. Above, the arm is held out at a 90˚ angle, so that its true length is shown. First, you need to break it down into its basic building blocks (right).

Step 2: Now, take those building blocks and change the angle. Imagine them pitched toward you. Your view of them alters – they appear shorter, perhaps fatter. If done correctly, your view of the arm appears shorter, not the actual arm itself. You have taken control of reality, in order to create something better than reality.

Step 3: As you gain confidence you can take things even further. In this example, the first shape is so large it almost obscures those shapes behind it. Once you have manipulated the building blocks into the position you favour, you can draw the details of the arm (or whatever object) around them.

HOW TO DRAW ULTRA CLOSE-UPS

Most importantly, you need an understanding of the human body. Practise drawing the whole human body, as well as certain limbs in isolation. Study a life model or use an artist's figurine.

You have another reference – yourself. You can use a mirror to study the figure in motion, or take photographs. Use a hand mirror for ultra close-ups. Weird angles are also fun and are the most dramatic.

When drawing larger heads, especially in close-up, you may lose the correct proportions. Features may drift, making them almost unrecognisable. Sketch them at a size you are comfortable with, and then blow them up larger on a photocopier to the size you want.

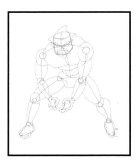 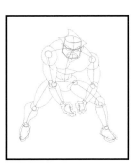 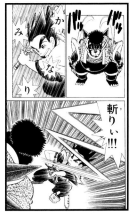

Above: Every artist has a degree of angle in their drawing. You may not even be aware of it. Check for this 'lateral drift' with a mirror.

Right: Here's a combination of nearly all the above techniques in a burst of super-speed Manga action.

YAIBA

ART OF SPEEDLINES
by Irene Strychalski

Speedlines are a great way of making your work dynamic. This step-by-step will help you to add zap to your art, combining foreshortening and speedlines.

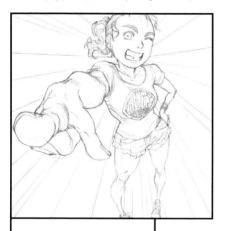

Step 2: I pencilled the character out, then drew a few loose speedlines with a ruler, going from the edge of the paper to her face, which is where I wanted to draw the viewer's attention.

Step 1: To make a speedline demo fun, I thumbed out one of my characters in an energetic pose. See pages 122–163 for detailed notes on character design and development. Thumbnails are a very rough stage, nothing has to look good.

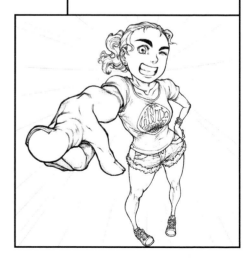

Step 3: Next I just inked the character in, using size 0.3 and 0.1 Micron markers. Making the outline on foreground objects darker pulls them forward and adds depth to your image.

Step 4: I filled blacks into her hair since it is dark... and finally got to the speedlines. I used a ruler, and made sure all the lines converged at the same vanishing point that I drew on her mouth in pencil.

Step 5: Using different sized pens, I add thinner lines and made them taper them toward the centre. Nibs actually work best for speedlines. I felt the lines were getting too unfocused, so I add some thicker lines in the corners. Be careful not to make a pattern with the lines – they should look natural and random. I finished up by screen toning her shirt and shoes.

WEIRD BUT TRUE

As an art form that originates from a culture and society very different from our own, it's surprising how universal the appeal of Manga is. Some elements, however, are less familiar than others. At times Manga seem nothing less than strange. Here are a few examples:

What's going on here? The character seems to be blowing a bubble out of their nose. This is the Japanese way of signifying that someone is asleep – their equivalent of snoring, perhaps, or of the 'zzzzzz' sound effect.

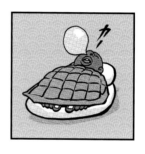

Sudden blank eyes on a character does not mean they are possessed by the devil or are a mutant mistress of the weather like Storm from *X-Men*. They actually show that the character is 'acting' or 'pretending'.

More than a simple nosebleed, this is an expression of lust – likely to be sexual in nature rather than literal blood-lust. This is called *hana-ji*.

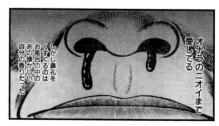

This little starburst effect could represent a throbbing temple, like a swollen vein (a Western equivalent would be 'GRRR!'). It is usually seen on the forehead of a character experiencing stress, anger in particular. It is also seen floating in the air near to a head but not on it, and at other times is superimposed over hair! So maybe it isn't a vein after all – but then it never pays to be too logical or literal with comics, especially Manga. They are, in essence, cartoons, and the limitations of reality are meaningless.

A slight outbreak of sweat expresses tension... but why settle for a slight outbreak when you can have super-sweat! A wonderfully bizarre strip serial, unique to Manga, is *Tetsuo, the Iron Man* (not to be confused with the movie of the same name, nor the shape-shifting character from *Akira*; the name is quite a common one in Japan). In this ongoing family saga, all of the tension in the stories revolves around embarrassment. As you can imagine, a lot of sweating goes on. This is by no means a hallmark of Manga alone – super-sweat occurs a lot in Western comics too, Tintin, for example. But in Manga it is taken to a whole new level.

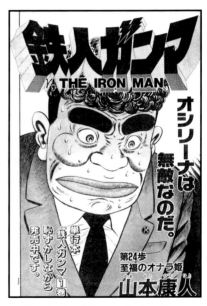

In this episode of *Tetsuo, the Iron Man*, Tetsuo gets into a fight with another man at the hospital, where they are trying to record his wife's farts! This is the reason for his nosebleed, shown opposite – an actual nosebleed as well as a symbolic one, which plays on the culturally accepted notion of *hana-ji* as a signifier for lust. Don't ask why they are trying to record Mrs. Iron Man's farts! It's embarrassing!

APPLYING TONES

As a mass-market medium, most Japanese comics are printed like our newspapers – in bulk and on cheap paper. For speed and economy, the artwork is produced in black and white. On a regular strip serial, a studio would be expected to produce at least 20 new story pages every week! The only time you will see Manga artwork in colour, apart from covers, is when it is adapted from an anime, as a special insert, or as a few pages at the start of a *tankubon* (a book collection of a popular strip).

Instead of colour, Manga artists make versatile use of tone. These grey tones are usually made up of a 'screen' of black dots. According to the size and density of the dots, they give the appearance of different shades, ranging from light to dark. Manga creators are adept at suggesting even the most delicate effects of light or mood through tone. Cheap printing makes very dark tones or large areas of black uncommon, but there's no reason for you not to use them.

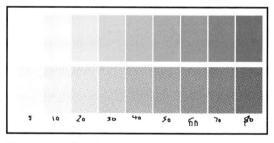

Tones are usually calculated as percentages of black (0% = white and 100% = black). Keep in mind that within any printing process there is usually a 10% gain in value. If you want a tone of about 20% black to appear in the printed comic, then you should use a 10% tone, even if it looks lighter than you want it to at the time. Anything above about 80% black might as well be black – that is how it will print. This is as true when working on a computer screen as it is on paper.

You can buy sheets of mechanical tone from an art supply store. Computers have largely taken over this area, but you should still find some useful supplies. Transferable sheets of tone may be rub-down transfers or adhesive. Choose carefully to make sure you buy the right tone for the effect you want. Be economical, and work from the outside of the sheet inwards, using only as much as you need. Save any leftover scraps.

With sheets of adhesive tone, you may either apply it directly to your page or place a sheet of clear acetate over your page and add the tones on that. Make sure your hands are clean before applying. Place the tone over the area where it will appear and then use a sharp scalpel blade to cut away the areas you don't want. Score, don't cut, or you will carve up your artwork too! With rub-down tone, use a hard pencil (2H–4H) and a hard surface, and burnish the area where you want the tone to come out.

DRAWN TONES

Tone effects can also be added using linework (hatching) or wash (watered down or thinned black ink). Any greyscale tone on your art, however it has been applied, will be screened for reproduction – that means converted to fine dots. Colour printing works in the same way.

A percentage tint. This one is 40% black.

A freehand tint.

COMPUTER EFFECTS

Most Manga artists use Photoshop to apply tones or colour to their line artwork. You too can explore the various drawing programs – look for pattern makers and halftone or 'pixelate' effects. You'll discover that working in 'layers' uses more memory but allows you more freedom to change your mind.

A repeating houndstooth pattern (good for snappy suits!).

A woodgrain tone. There are many other natural and artificial patterns.

TONE EFFECTS

You can apply tones to your artwork to achieve many different kinds of effects. Sometimes the aim is to make a scene look more solid – other times you want to reflect a more intangible mood or feeling. Darker tones, for example, have their own suggestive, more sinister edge.

First we will observe atmospheric effect or impressionistic tone, which is suggestive of different times of the day. Can you work out the position of the light source in each of the panels below?

Tone isn't just used to create light and shade. It can also be used to recreate certain textures (as we have seen on the previous page), from patterns on clothes to more natural elements such as tree bark.

This is how a panel might look before any tones have been added. The line drawing, depicting the corner of a building, remains exactly the same throughout. In each of the following versions, tone is used to suggest different times of day.

A light tone suggests a daytime sky. Manga artists sometimes suggest clouds by painting white over the top of the tone. Alternatively, they scratch certain areas away to reveal the white underneath. Both techniques produce successful effects.

Is it early morning? Or early evening? The light might throw a shadow on opposite sides of the building, according to whichever it is (a rising or setting sun). Note how it is darker inside the room than it is outside.

When adding tones to your images, think about the nature of your light source – where is it? Is it artificial or natural? These elements will affect how and where your shadows are cast. The contrast between areas of light and dark will govern how dense and how varied your tones might be.

Here's a cool-looking *shonen* Manga character. At the moment he looks a bit blank, but with the addition of tones he will look better.

In this panel a light tone has been applied to give him light-coloured hair. Don't forget to add tone to his eyebrows too!

A more complex use of tone suggests a strong light source. A graduated tint in the background creates a 'halo', reinforcing his expression of surprise.

Another way to focus the attention is to tone every other part of the figure except where you want it to go – in this instance his eyes, which seem to glow white against the darker tones.

You can apply the same principle as before, but isolate the figure against a tone background so that it really stands out. Consider also the mood or immediate environment.

A close-up detail from the previous panel. A limited use of tone, but of two different shades, makes the character's eyes the focal point of interest in the image.

COLOUR THEORY

As a subject, colour technique requires a book by itself. You may want to colour at least a cover image or pin-up for your Manga, so here is a brief outline of the basic principles involved. If you want to learn more about colour there are textbooks available that specialise in the subject, but make sure they include print media.

Printing technology is undergoing change, but at the moment four-colour printing is still the norm. Almost every full-colour image you see is made up of percentage dot screens in four colours – Cyan (blue), Magenta (pink), Yellow and black (which is 'K', just to be confusing). Together they make up 'CMYK'. There is also one- or two-colour printing, where the ink colours are created for specific areas of spot colour. Some of the images in this full-colour book have been given the appearance of two colours (usually black line and 30% cyan tone), to mimic this technique. Simple or even single-colour treatments can be just as effective as psychedelic ones.

There are more badly coloured comics than there are of those coloured well. Look at some on a shelf display and you will notice that few really leap out from the rest. Before starting out in colour, it is best to limit your choices by making up a swatch or palette, such as that on the right, or you could find yourself thrashing around forever in a psychedelic sea of indecision. Decide beforehand what colour range best suits the mood, atmosphere and message of the image you want to create. Alternatively, limit yourself to shades of a single colour (often very effective) or two contrasting colours. Mix your limited range palette and stick to it. Try not to introduce any other colours. You will discover that simplicity works in your favour.

COLOUR CHOICES

Certain colour combinations can be 'complementary' (pleasing to the eye) because they assume a similar value, even though they appear quite different. Red (M/Y) + green (C/Y), orange (M/Y) + blue (C), and purple (C/M) + yellow (Y) are examples.

If colouring by computer for printed comics, it's important to remember that the printed colour will differ from the colour you see on screen. It is best to colour in CMYK mode, available as an option in most programs – it feels limiting, but at least you know what you are getting.

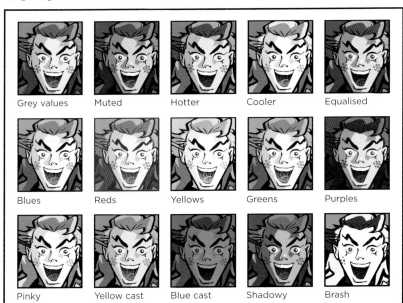

Grey values	Muted	Hotter	Cooler	Equalised
Blues	Reds	Yellows	Greens	Purples
Pinky	Yellow cast	Blue cast	Shadowy	Brash

ANIME-STYLE COLOUR

In practise, colour does not feature greatly in authentic Manga, as already explained. In theory, however, there's no real reason not to use colour if you want to. Manga does occasionally appear in colour as special inserts in *zasshi* or at the start of a new book collection. Manga adaptations of anime movies are also increasing in popularity. Full-colour pages are created from the animation itself – reformatted, lettered and laid out in panels just like Manga. Adding colour to an image takes it into yet another dimension, as different from black and white as ink is from pencil.

Joker, the leader of the Clown Gang from Katsuhiro Otomo's sci-fi saga *Akira* (2,500 pages, six volumes). Manga-creator turned movie director, Otomo himself led the production of his story as a feature-length animated motion picture. *Akira* the movie was a massive worldwide hit, hugely influential and a first introduction for many people to the furious futuristic worlds of anime and Manga. Observe the master drawing (above left), drawn with a technical pencil containing coloured leads. If the main image (right) looks a bit flakey or blurred, that's because it is taken directly from one of the movie's 160,000 original cel paintings! Many hundreds of these had to be painted for every single scene of a two-hour movie – not only figures, but backgrounds and special effects. The same techniques are largely done by computer these days.

The clean, crisp look of animation cel-painting suits the more open line styles of Manga. The cel images of Joker (see below) are a good example of the basic thinking behind the technique. In the line drawings, notice how the separation of areas of light and shadow has been indicated with a blue line. Depending upon the light source, shadow falls on one side of the line or the other. This describes each area in terms of two tones.

Step 1: Take your drawing and select the area you wish to colour. Divide it accordingly, indicating areas of shadow. See the line in your mind or sketch it on a rough copy of the art, otherwise your colour art will be full of blue lines.

Step 2: Choose the basic colour of each shape first, and derive the lighter and darker shade from this. Two shades of the same colour are normally best, unless you want a high contrast.

Step 3: Add in more white or yellow to lighten the tone or alternatively add blues or blacks to darken.

Step 4: Apply the same two-colour process to each part of your image. Try to suggest a consistent light source.

TEXTURES AND SHINES

By experimenting with inking implements and studying examples of original Manga, you should be able to replicate most of the effects that you want. Here are a few tips on techniques to get you started.

THE RIGHT TOOLS FOR THE JOB

If you can't achieve the effect you want with the tools you have, get yourself along to the nearest art store and experiment with other materials. Brushes are made from all sorts of animal hair and artificial fibres, and come in a great range of sizes.

You should at least have a small brush for fine detail (0 or 00), as well as a medium to large one (4) for bolder strokes. For sharper lines keep the brush loaded, but drag the tip against the lip of the ink bottle to remove excess. As the brush runs out of ink you get 'dry brush' effects, which can be useful in themselves.

For large areas, use a cheap brush or a cotton bud. You will find it quick and simple to fill in large areas of black or colour with these.

A china marker gives a black but textured line, especially in combination with paper stock that has a 'tooth' (or a rough surface).

Create an artificially roughened surface by first applying correction fluid to the area you are going to texture, then laying in china marker over the top. The effect you get depends on how hard you press. As with most tonework, it prints darker than it looks, so be subtle.

To suggest a chalk outline like that of a body, use a china marker to draw the line, then blow it up larger. Make it 'reverse out' (or 'invert') so that the black becomes white and vice versa.

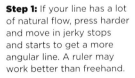

By touching the pen to paper just a few times, dots and dashes in decreasing amounts can appear to recede into the distance – good for a gritty floor and wall surfaces. By applying dots to some areas but not others, you can suggest the effect of sunlight and shadow.

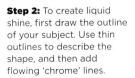

Use the following inking techniques to suggest a metallic finish – good for *mecha* – or experiment and come up with some of your own.

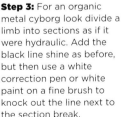

Step 1: If your line has a lot of natural flow, press harder and move in jerky stops and starts to get a more angular line. A ruler may work better than freehand.

Step 2: To create liquid shine, first draw the outline of your subject. Use thin outlines to describe the shape, and then add flowing 'chrome' lines.

Step 3: For an organic metal cyborg look divide a limb into sections as if it were hydraulic. Add the black line shine as before, but then use a white correction pen or white paint on a fine brush to knock out the line next to the section break.

Step 4: You can add white paint or correction fluid to black but the white needs to be thick to reproduce well, making it hard to handle.

THE ART OF COLOUR
by Irene Strychalski

Sometimes a simple use of colour can make all the difference to your artwork. This step-by-step will help bring a drawing to life.

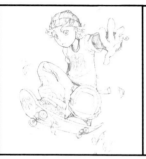

Step 1: I worked out the colour scheme I wanted in the thumbnail. I like to colour traditionally with Faber-Castell brush pens, as they're easy to carry around and don't bleed through like Copics. I've never had a problem blending Faber-Castells either.

Step 2: I pencilled my little skateboarder in, but changed the positioning of his head, as it would be more natural for him to be watching his way.

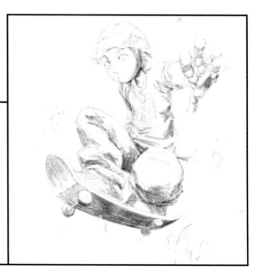

Step 3: I lightened the pencils by dabbing them with a kneaded eraser, and established the light source first with a 10% grey marker.

Step 4: Next I outlined the areas of colour and drew the logo designs. I filled in all the light colours, leaving white areas blank. Markers are very similar to watercolour.

Step 5: Then I filled in the dark colours. The black ink comes after this when working traditionally, so the markers don't smear the inks.

Step 6: Last, I added white minimally to his skin and to shine up his skateboard.

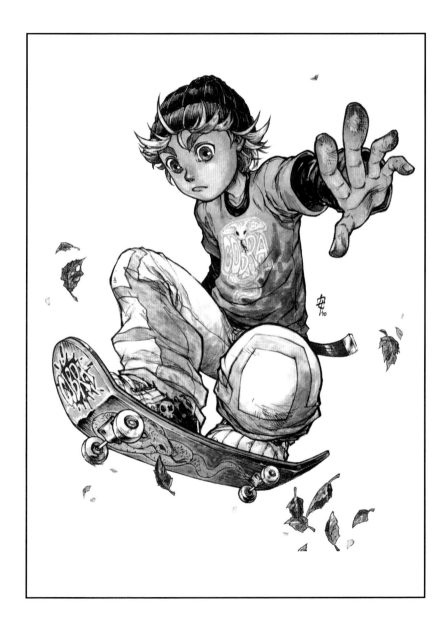

CHAPTER 7

CREATING WORLDS

MANGA ISN'T JUST ABOUT THE CHARACTERS YOU CREATE, BUT ABOUT THE ENVIRONMENTS THEY INHABIT, TOO. THESE MAY BE REALISTIC, FANTASTICAL OR EVEN TOTALLY MINIMAL.

CREATING WORLDS

The joy and freedom of Manga is to be found in the creation of an entire universe. It may seem daunting to have to start with an empty sheet of paper, but once you have ruled up the margins and worked out how many panels will appear, that sheet of paper is no longer blank – it's ready and waiting to receive the flow of ideas and images from your pencil or pen. You can draw reality as you see it, or even totally depart from reality. When establishing any kind of world on paper, though, you need to make sure it is convincing or the reader will not feel a part of the action. One way to do this is to create the illusion of depth.

Darker tones and thicker lines mark out the foreground (the area that appears to be nearest to us). This composition has been designed with a single aim – the 'gate' of tree trunks, overhead canopy of leaves, rolling hills and winding path all direct us toward a bridge and the entrance to a great fort beyond. A darker circle defines and limits the visible horizon. We may be going in, but there's no guarantee we'll be getting out again. Also note the exaggerated contrast in scale between the small figure, Kitsune, and the giant badger guards.

These pages are reproduced from *Kitsune Tales*, a comic by Woodrow Phoenix (writer) and Andi Watson (artist) published by Slave Labor Graphics in the US. Kitsune is a character from Watson's long-running series *Skeleton Key*. She is a fox spirit, based upon various Japanese folk tales, a milieu to which she returns here. Even in a relatively abstracted style of bold marks and broad strokes, Watson elegantly evokes an ancient and proto-Japanese landscape. Air, space and the gentle sound of a waterfall and river makes the scene an invitation to the reader. Enter, and lose yourself for a time.

HYPER REALITY

While the characters in Manga are often bizarre and cartoonish, other details about them or around them may be described in terms of realism. The aim is not necessarily to appear realistic, but to be convincing. Even the most bizarre fantasy worlds need to have some element grounded in reality, otherwise we have no frame of reference and will not relate to the story. In the same way, many surrealist artists such as Salvador Dalí employ very realistic art styles.

Realism in some areas allows for more extreme stylisation in others. For example, you may want to have a realistic background and stylised figures, or a stylised background and realistic figures.

KUROKUMO

Hair tends to be very carefully depicted – when it's not spiky and perpendicular, the waft, weave and flow of individual strands is observed and delicately crafted. Shine is depicted in tone or colour.

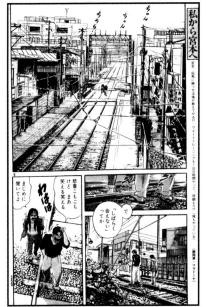

Miyamoto Kara Kimie 'From Miyamoto to You'

In this strip by Hideki Arai (left), a tragicomic soap opera of young lovers set in modern-day Tokyo, the backgrounds are obviously recreated from a photographic reference. The images of the city have been expertly redrawn, leaving out any distracting shade or detail. The scenery becomes something more than real – it has been adapted to suit the author's story. We do not get very close to the characters on this particular page, but if you look closely their faces and figures are not as realistic as the background. Isolated within a hyper real landscape, the two characters are united in discord. Their portrayal goes beyond mundane reality.

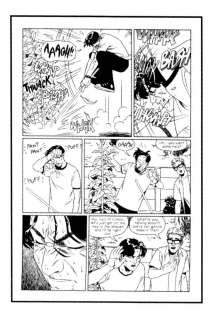

There are instances where exaggerated facial expressions are intended to be humorous.

Even in the midst of a naturalistic Manga style, the faces of characters may suddenly become hyper-emotional and 'cartoony'. This shows the influence of the characterisation of *chibi* throughout other forms of Manga. See the example, left, by American cartoonist Derek Kirk Kim from his book, *Same Difference*. In this context, *chibi* style is adopted as shorthand to indicate when a character is being cute or funny.

WRACK AND RUIN, ROCK AND RULE

For too many years the American comic industry has been saddled with a contradiction – two mutually exclusive hangovers from the 1970s. First, the false limitation put upon genre – superheroes and nothing but. Second, a concern for realism above all else. This creates a need for continuity that is overblown (for characters whose adventures stretch back decades, and are myths anyway). Plus an entrenched scorn for styles seen as being 'too cartoony'. The fear is that reading comics might be perceived as childish. Realistic superheroes, or superhuman reality – in trying to go in two directions at once American comics are pulling themselves apart. As a result the 'funnies' of old are out of touch with recent generations. Thank heaven, then, for Manga. They have blown in from the East like a breath of fresh air, inspiring a new generation of cartoonists. Comics thrive in Japan because they have no such hang-ups about combining their fantasies with their reality, and vice versa. Superheroes rock, but the hyper reality of Manga rules!

PERSPECTIVE

How do you make your backgrounds and landscapes convincing? The answer is perspective. It provides a sense of where you stand as a viewer, and where characters, objects and environments exist in space – a space that isn't really there! Handling perspective is not as complex or dry as it might look. Probably the best way for you to understand the thinking behind it, and to put it into practise, is to take a pencil and ruler and copy out exactly what you see here. You can then adapt what you have learned to your own story situations. Every panel in comics has an imaginary horizon line, according to the angle from which its content is drawn and 'viewed'. Your eye will always be on a level with the horizon line, even though you may be looking down on a scene, or up at it. The horizon line shifts according to the position you are looking at things. Study the three sketches of a chair below, which should make the distinction more obvious.

HORIZON LINES

Step 1: This angle is as if you are sitting looking across at the chair. The horizon line is above the chair.

Step 2: This angle is looking from the floor up towards the chair. In this instance, the horizon line is level with the chair.

Step 3: In this example, the view is from below the level of the chair. The horizon line is therefore below the chair.

ONE-POINT PERSPECTIVE

Imagine that the chair has fallen over, and you are looking down at it. Follow the lines of the angles and extend them until they appear to join. This is called the vanishing point, and is on the same level as the horizon line. This is one-point perspective. To draw a chair like this, do all of that in reverse. Establish a vanishing point first, then your horizon line, and from the vanishing point extend lines outwards. Depending on how big (or near) the chair is in your view, at some point along those lines draw a chair.

TWO-POINT PERSPECTIVE

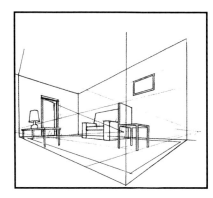

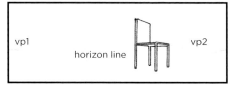

If the chair was in a larger view of a room you would plot the other fixtures and fittings according to the same perspective. It might be easier to plot the perspective of the room first, and then place the chair in it. You would probably expect the fixtures (walls and floor) and their fittings to align in perspective, but real life is messy – other furniture might be arranged at different angles. Notice how the door that's just slightly ajar involves a whole new vanishing point (between the back legs of the chair). It shares the same horizon line, but a different vanishing point.

ENVIRONMENTS

Now that we've explored interiors, let's go outside and explore exteriors. If you were to look straight down the middle of a street, you would be viewing single-point perspective (see right). The old-fashioned low-rise buildings and high-rise city blocks appear to recede as they near the vanishing point.

ONE-POINT PERSPECTIVE

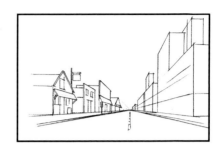

TWO-POINT PERSPECTIVE

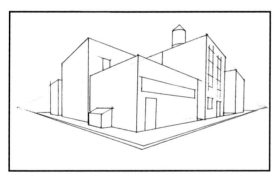

When looking at square or rectangular buildings or other solid objects in a cityscape or landscape from a different angle, two vanishing points are apparent, relating to the two sides of the object. These vanishing points converge on two separate points on the horizon (as seen in the diagram above). In a big city you are bound to get some crazy perspectives, especially with all those skyscrapers. This is when you start to get into the territory of three-point perspective, and things start to get a bit hazy. For these more complicated shots, establish your construction lines and vanishing points so that you have accurate points of reference. You can usually judge things accurately by eye. Anything incorrect will draw attention to itself. If it spoils the illusion you are attempting to create it is best to take up your ruler and puzzle it out.

In this high-rise cityscape, a high horizon line using single-point perspective yields a surprisingly effective result. There are all sorts of other estimated minor perspectives going on, from multiple vanishing points, but drawn with confidence they are convincing without strict mathematical accuracy. All the same, you'd have to like this sort of thing to be able to do it.

The techniques of perspective are complex, and you may find them difficult to grasp at first. Do not get disheartened. There are plenty of books on the subject that go into greater depth. Still, if it completely defeats you, you might want to consider setting your Manga somewhere other than straight-up-and-down rooms or big cities. You can always set your Manga in fantasy realms where natural forms are endlessly variable and the normal rules of gravity might not exist – but even here, you will find knowledge of the most basic perspective serves you well. As long as you have an understanding of single-point and two-point perspective, you will find it possible to recreate most scenes. Do not avoid backgrounds entirely, or your characters will have nothing to interact with and nowhere to go!

THE ART OF SIMPLICITY

Less is more. It may not seem so with all the speedlines, thousands of pages, or the sometimes ornate surface style, but nothing is more true of Manga than this. At their best, Manga are dynamic, direct and deliberate – the blow a samurai seeks to strike with his blade.

Simple images work best of all, because they communicate quickly and efficiently. Detail should be added for no other reason than to create mood or a sense of time and place. The essential image should be direct – immediately understandable on an almost unconcious level – in spite of how much detail is added, whether a great or small amount. At no time should your reader be unsure what he/she is looking at, even for a split second, unless that is your very deliberate intention.

Too many lavish illustrations may impress the reader, but they can also interrupt the flow of your story. You want the readers to forget themselves, and to become a part of the action. Showing off will just distract them. Always bear in mind that individual panels on a page are a means to an end, not an

end in themselves. Manga is about storytelling, and this storytelling is centred around the rhythms of panel and page layout.

It's certainly true of other comic book styles, if not Manga, that a lot of linework or too much detail is often employed to disguise weaknesses in other areas. This usually indicates that basic figure construction or page layout is lacking or has been haphazardly put together. This will also obscure the storytelling.

Although most Manga make use of speedlines, and backgrounds can often be highly detailed, the drawing of characters usually remains simple. This makes it easy for the artist to recreate the same character from page to page.

Even comic book editors can mistake quantity for quality. Some ascribe a value to the density of linework – pounds per square inch, or 'getting their money's worth' – as if they were buying vegetables at the market! When it comes to good storytelling, such thinking is just plain wrong. Proof positive, as you will very soon discover for yourself, is that it often takes more time and more effort to draw less. In good comics, it bears repeating, less really is more, as the images on this spread demonstrate.

CHAPTER 8

CHARACTER DESIGN

START WITH A CHARACTER...
THIS CHAPTER SHOWS YOU
HOW TO COME UP WITH
AND DEVELOP YOUR
CHARACTER DESIGN.

CHARACTER DESIGN

You are going to need some ink and a brush (and maybe another brush or two). Check out page 104 and buy what you will need ahead of time.

SKETCHES AND TURNS

When developing characters, it is best to sketch them many times over. Work out how they would look in different poses, or in different moods. Use the method of structure shown earlier in the book to make sure they are recognisable from any angle (see pages 36–39). Create a set of 'turns' for each. Then, line them up so that the height remains the same. Draw them front on, in profile (side on) and from behind. When drawing your Manga, keep a sheet with your character sketches at hand or pinned up in easy view as a constant reminder. It will make your job a lot easier!

WING

Wing, by Wing Yun Man, is a character designed for her Manga *Telephone Ice Cream*. In the sketches she is drawn *shojo*-style, but in colour turns *chibi*-style. 'The tail shaped like a bird's head is a bit of a mystery,' says Wing.

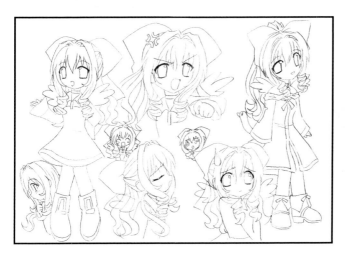

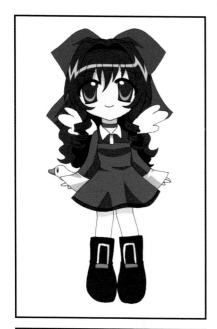

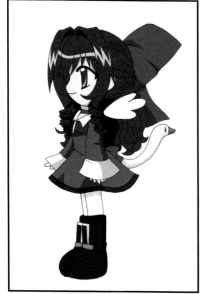

EVEN A SINGLE IMAGE (OR PIN-UP) TELLS A STORY. A GOOD CHARACTER DESIGN WILL CONTAIN WITHIN IT A WEALTH OF STORY SUGGESTIONS. FROM THESE YOU CAN DEVELOP A PLOTLINE FOR YOUR MANGA.

DRACONIS

A bit of mystery always draws in your reader, so here's a more mysterious-looking character, Draconis. As the name, colours and dress might suggest, he's something of a villain. 'Evil, quiet, clever,' says creator Wing Yun Man. 'Likes: relaxing, taking over the world, reading books. Dislikes: children, loud noise.' This sort of detail, conceptual and visual, is called characterisation.

He too is shown here in his normal guise (as a *bishounen*, or sexy guy), and – in the character turns opposite – *chibi*-style. The significant parts of his design are his long strands of hair and the belt-like leather ribbons tied around his upper arms. When this figure is in motion these elements trail behind, adding direction and dynamism to the action. Also observe his weird and creepy single 'glove' and accompanying bat-cat, who looks equally evil and menacing.

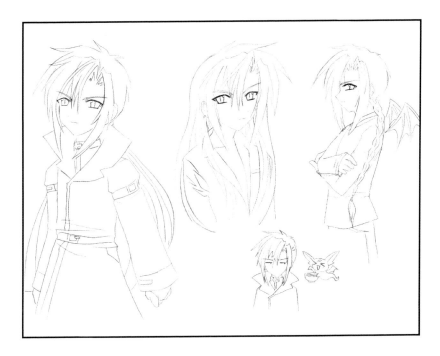

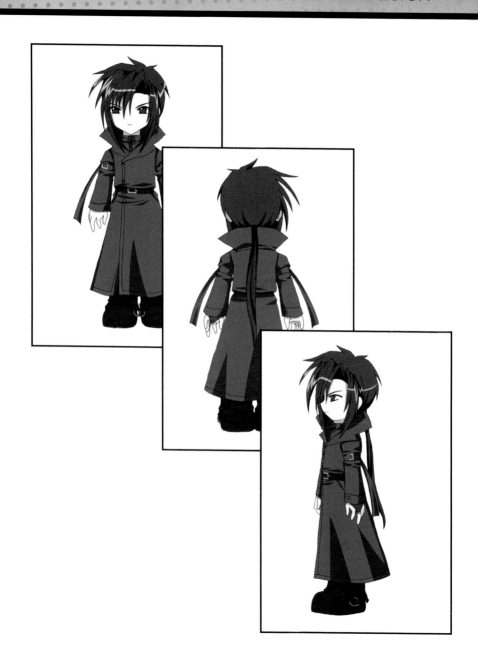

CREATURE FEATURES

PIKO, PINKO AND HISSY

Here are some mascots (you may have spotted one with Draconis on page 126 – his bat-cat, Shinra). These work best when kept simple and iconic.

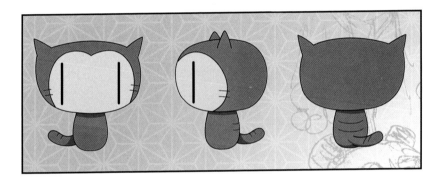

These cat-creatures all share the same basic shape but have different features and colour schemes. You will notice this about vinyl toys and action figures – they often come from the same sculpt.

Even while they remain simple, you can tell a lot about their individual character from these details.

Piko, Pinko and Hissy

Many funny animal characters like these appear in short stories, colour inserts or three- to four-panel 'gag' strips called *4-Koma*. Appearing in most *zasshi* titles (for all ages) these are included as *omake* (or 'bonus material'). If successful they spin off into animated series and spring up virtually everywhere as tie-in merchandising icons (or 'mascots') – as vinyl toys, plushes, buttons, t-shirts, stickers, dolls, novelty keyrings, the works – earning their creators millions.

Above: Cursed by his panda metabolism and a high-cholesterol diet (he prefers donuts to bamboo shoots and leaves), this is giant panda Big Bam Boo.

Left: More cats, from the pen of Scottish cartoonist Craig Conlan. In this very simple one-page strip he shows six completely different cat designs. Compare them to Piko and Co., opposite and above, and robot cat Doraemon or What's Michael?.

CHARACTER DEVELOPMENT

ON THE WARPATH

Manga is not all sweetness and light – far from it. For those whose tastes run to something a little darker, here is an original presentation drawing featuring a far more dangerous set of characters.

They are the central cast of an action-adventure serial called *Warpath*. A loose alliance of outcasts and misfits, a 'gang of gangs', they must fight in a desolate, futuristic Los Angeles. They will star in a short Manga sequence, a working example of the development of a project. The techniques and sample materials that follow will take you through every stage of the process – from first sketch to finished pages.

Warpath was originally conceived as an American-style comic, so it first needs to be recast as a Manga. Although Manga can be drawn in any style, we will steer away from a naturalistic look and make the character designs less realistic and more stylised. This will partly involve emphasising the characters' different body shapes and their relative sizes, as illustrated in the images on the opposite page.

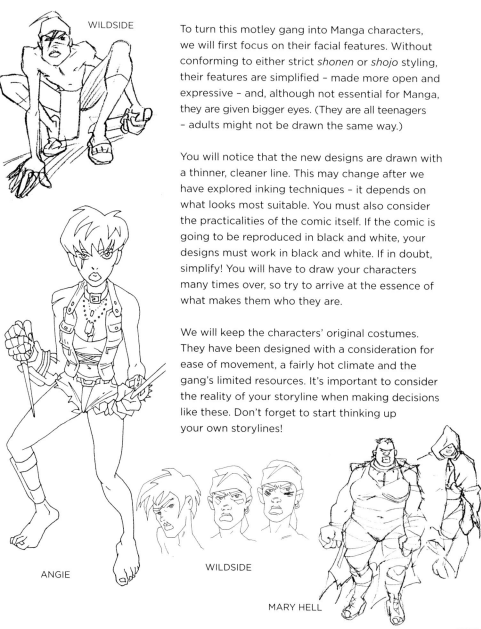

WILDSIDE

To turn this motley gang into Manga characters, we will first focus on their facial features. Without conforming to either strict *shonen* or *shojo* styling, their features are simplified – made more open and expressive – and, although not essential for Manga, they are given bigger eyes. (They are all teenagers – adults might not be drawn the same way.)

You will notice that the new designs are drawn with a thinner, cleaner line. This may change after we have explored inking techniques – it depends on what looks most suitable. You must also consider the practicalities of the comic itself. If the comic is going to be reproduced in black and white, your designs must work in black and white. If in doubt, simplify! You will have to draw your characters many times over, so try to arrive at the essence of what makes them who they are.

We will keep the characters' original costumes. They have been designed with a consideration for ease of movement, a fairly hot climate and the gang's limited resources. It's important to consider the reality of your storyline when making decisions like these. Don't forget to start thinking up your own storylines!

ANGIE

WILDSIDE

MARY HELL

CREATION OF ERWIL
by Elli J Puukangas

Being creative is essential when developing a Manga character. Combining mythology with fantasy is a fun way to inspire an idea for a character.

Step 1: Erwil started off as a small troll character from childhood stories that my mother and grandmother used to tell me. She was a messy-haired, pointy-eared mischievous forest spirit, like the trolls in Scandinavian folklore. I also adored dragons and the tales and legends behind them, and wanted to include that aspect in her design as well.

Step 2: Erwil was a relatively simple character at first, but grew and evolved a lot over the years. I studied many different folklores and religions, but most inspiring for me were the Norse ones. Erwil made friends, gained powers, and even changed gender, but the base idea is still there. A character that was inspired by the tales of the old, legends, myths and nature.

Step 3: I start drawing the basic sketch – either with a blue pen traditionally, or in Photoshop with a mechanical pen – to establish the proportions and angles.

Step 4: For inking I use either Pigment Liner inks, or if I'm working in Photoshop, a mechanical pen and the Small Sharp Brush tool to give the characters more traditional look.

Step 5: When colouring, with a mechanical pen, I usually work on a single layer. Use a Small Sharp brush, at around 15–25% opacity, and use broken colours to colour under the inks.

Step 6: At last, add the highlights on a different layer on top of the inks and add background. The background was created on multiple different layers with a Large Soft brush. The star cluster was added with a Small Sharp brush in irregular order.

DIFFERENT STROKES

It may seem as though we have only just started developing our characters (and we have!) but let's turn our attention to working in ink, since it will affect the way we portray them. Manga, as with any comic style, is the end result of a combination of different diciplines.

IF YOU HAVEN'T ALREADY, IT'S TIME TO EXPERIMENT WITH INK PENS AND BRUSHES, AS WELL AS ANY OTHER MARK-MAKING DEVICES YOU CAN LAY YOUR HANDS ON. FOR SOME OF THESE YOU WILL NEED BLACK WATERPROOF INK. IT MAY BE CALLED INDIAN INK, OR CHINESE INK. IT'S BEST TO USE THE SAME BRAND OF INK FOR YOUR BRUSH AS YOU USE TO REFILL YOU TECHNICAL PENS — IT'S MORE EXPENSIVE, BUT BLACKER. CHEAP BLACK INK CAN LOOK BROWN OR BLUE!

Technical pens produce a steady, true black line with no blobs or drop-out. The nibs come in varying sizes, but below about 0.4 mm they tend to snap easily. Isograph pens have a refillable cartridge, whereas rapidographs use disposable cartridges. Pens suit meticulous fine line detail and a slow hand, but are high maintenance and don't come cheap.

When you can, use a brush for the most expressive linework. Brushes come in many different types and sizes and you tend to get what you pay for. Brushpens come in a variety of tip sizes and are handy because they don't drip.

Quick and easy to use, felt-tips are handy for speedier, sketchier drawing but wear down quickly - causing drawn lines to become fatter. They are cheaper, but need regular replacing (you just can't win!).

MAKE YOUR MARK

Take time to become familiar with the variety of marks that can be created with different drawing tools. Get some scrap paper and try anything and everything. Scribble for hours.

Whatever your emerging drawing style, keep in mind that clear, definite lines tend to work best for comics, rather than sketchy, unsure marks. You will soon discover what works best for you, and start to evolve your own personal style.

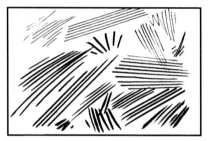

PRACTISE, PRACTISE, PRACTISE

Skillful drawing is all about manual dexterity and hand-eye coordination. Often you can see a drawing in your mind's eye, but you haven't got the hand skills to realise it. But it does get easier. Just draw, and draw, and draw. Then draw some more. There is no other substitute.

Bored? Nothing on? Nowhere to go? Waiting for a bus or a doctor's appointment or a sunny day? Draw, scribble, make notes. Whatever else you may be doing, carry a small sketchbook around that you can add to. No ideas? Just doodle. Sketch what's in front of you. You can make Manga wherever you are.

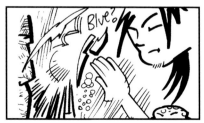

INKING CHARACTERS

Much of your character's look will be created by the way in which you ink him or her. Although it is something of a generalisation, in Manga you tend to have more delicate linework – a thinner line – than in other kinds of comic. Also, you will not usually see many areas of solid black. This is not an aesthetic (artistic) choice, but usually due to the way they first appear in print – in black and white and on cheap paper (serialised in *zasshi*). This is worth keeping in mind before adopting this look, as you may have no real need to! As working examples, here are some more drawings for the Manga remix of the original *Warpath* concept.

Use a variety of line thicknesses to add more 'character' to your drawings. Compare the images below to the way they appeared on page 131. Areas of 'spot black' add focus, drawing attention to certain areas of the face (eyes – the iris or as here, entire pupils) or emphasising an expression (brows, top lip). Other objects may simply be defined as black in colour. A stronger line under the chin or even a cast shadow, helps to 'ground' the figure (or give it weight and presence in space). As a Chicano gang-member basing his look on Native Americans, Wildside wears warpaint on his cheeks. Also, lines added to cloth can create texture – see his headband.

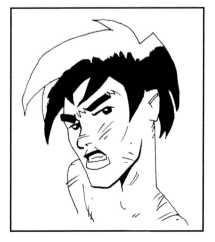

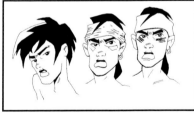

Early on in the *Warpath* story, Wildside is a fugitive on the run after his defeat, capture, and escape. To reflect this he is 'dirtied up' and scars have been added to suggest an unwashed, 'battle-ravaged' appearance. Notice how far the character has developed from his look on page 131.

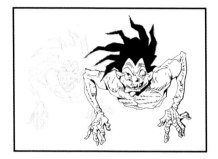

Check out these two figures of Oddbod (you don't want to know what he's been through to get that way). Notice how the various inking principles outlined opposite have been applied to the body as a whole. Or in this case, half.

Since the *Warpath* story is set in Los Angeles, thin linework and minimal touches of solid black give the pages a sun-bleached look – suggesting the heat and blinding sunlight. The open style of the drawing below relies on the use of controlled line. See how effective a few touches of black shadow are for defining shapes and objects. A black bar on Angie's sheath (lower right leg) with some lines struck through it suggests the shine of leather, as opposed to, say, cloth or metal.

In the beginning Angie appears to be an ordinary civilian; by the story's end she has shown her true 'colours' and reverted to type. An ex-member of the Scar Babies – having been expelled for surviving long enough to have grown up – she is, at 16, a combat veteran.

As part of his gang costume, Wildside wears US Cavalry trousers (in the style of native scouts in countless Westerns). They are dark blue with a yellow stripe, so hatching (short lines or dashes) has been used to suggest this. In this case the rough look suits a rough story – a neater solution might be to use mechanical screen tones.

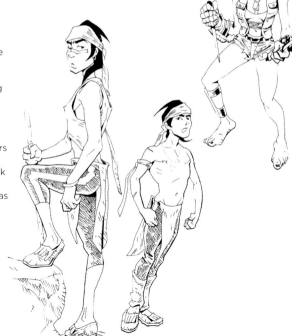

DRESSING FOR SUCCESS

Give careful consideration to the way your characters are dressed. Do they wear cloth or metal? Armour perhaps? Are their outfits worn for protection? Disguise? Decoration? Ceremony? Are they simple? Extravagant? Built for speed? Close-fitting or loose and flowing? Daywear? Nightwear? For summer or winter? For show or stealth? Are their costumes an accurate reflection of their characters? Villains tend toward extravagance – grander shapes and sharper lines to match their spikey personalities. Pick up books on costume design appropriate to the era in which you wish to set your story. The style of the samurai (bottom left) is given a modern twist.

Even cute can be menacing. From his *chibi*-Manga-influenced series *Samurai Jam*, here's a picture by Andi Watson of his urban-myth hockey-demon Otaku. A sort of Freddy Krueger on ice!

Characters from *Yotoden* (*Wrath of the Ninja*).

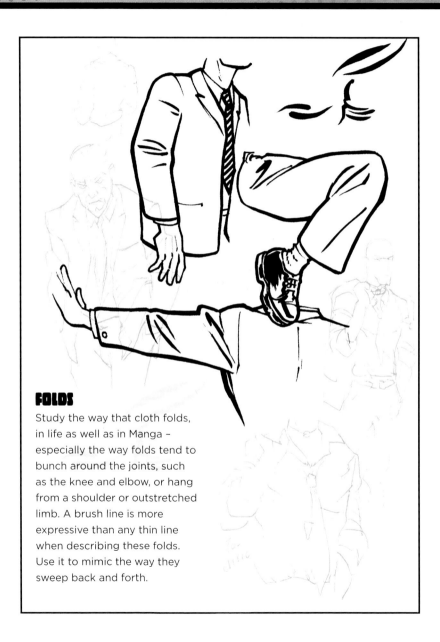

FOLDS

Study the way that cloth folds, in life as well as in Manga – especially the way folds tend to bunch around the joints, such as the knee and elbow, or hang from a shoulder or outstretched limb. A brush line is more expressive than any thin line when describing these folds. Use it to mimic the way they sweep back and forth.

KANJI

Japanese was a purely spoken language until the fifth century AD, when Chinese ideograms were adopted as a writing system. These are *kanji*, meaning 'writing system of the Han Dynasty'.

Kanji mostly retain the same meanings in Japanese (*kun*) as they had in Chinese (*hon*), but they are read in a totally different way. In a similar fashion, Europeans adopted Arabic numerals 1, 2, 3, etc., which are also ideograms – these subsequently travelled to the Americas. Every 'ideogram' expresses a concept and not a syllable (or sound) – a word rather than a single letter. Instead of an alphabet, they bear more relation to pictures in miniature. Small wonder that comics should become so popular in a culture where communication is based upon pictures!

BRUSH TIPS:

• Lip it! Lick the tip of your brush (before you dip it in the ink!). It helps to gather the hairs together.

• It may be worth a careful trim with scissors if any single hair is too long.

• Don't stab with the brush, or it'll only be fit for sweeping floors.

• Take good care of it – wash it clean after use before putting it away. If you leave ink to dry on it the brush may clog for good.

KANJI EXERCISE

Use a brush or a brushpen to copy the *kanji* words for 'Manga', 'rising sun' and '*shojo*'. These ideograms are printed in blue line for you to trace over, working directly on the printed page. See how the different stages might work, in the smaller example below.

Ni 'sun' + *Hon* 'origin' = *nihon* 'rising sun' – the *kanji* for 'Japan'.

Man 'rambling' + *ga* 'image' = *manga* – the *kanji* for 'comics' in Japan.

Sho 'little' + *jo* 'woman' = *shojo* – the *kanji* for 'little woman' (or 'girl').

CHARACTER DEVELOPMENT

On pages 30–47 we looked at examples of character design by different artists in a variety of styles. Now it's your turn. If you haven't yet come up with a character or set of characters of your own (to appear in your Manga comic), then the following tutorials and hands-on exercises should help. As you work through them, think about your own central characters and Manga storyline – don't forget to sketch out all of your ideas.

The style in which your characters are drawn is less important than the way in which you tell your story – it is the storytelling that makes Manga. If, however, you are a bit of an *otaku* (obsessive) – welcome to the club! And if you are, you may want to introduce more 'typical' Manga styling into your character design (but don't feel you have to). On the following pages we examine how to replicate a couple of the most popular genre styles, as well how to arrive at your own original solutions.

OTAKU – A FANATIC, OR OBSESSIVE FAN (WE MIGHT SAY 'FANBOY', 'FANGIRL' OR SOMETIMES 'GEEK'). MAY BE MEANT AS AN INSULT, BUT OTHERWISE EMBRACED AS A BADGE OF HONOUR.

BISHŌJO – (OR BISOJO) – ULTRA-SHOJO. MORE THAN A GIRL, A BEAUTIFUL GIRL! LIKEWISE, BISHONEN – 'BEAUTIFUL BOY'. HELLO? MY NAME'S BUNNY, REMEMBER? HEY, LOOK AT ME, NOT HER!

GEEK

WORK IN PROGRESS - BISHŌJO

Here, Manga artist Wing Yun Man shows us how she develops one of her characters step-by-step, from initial sketch to inking and final artwork. The aim is to create a dark *bishōjo* character.

The design of *bishōjo* and *bishonen* depends on what you find (or think your audience will find) sexy. At first, explore your options with a few rough sketches. Elaborate on the details that work for what you have in mind. Sometimes your pencil will have to search and search, or the perfect character may pop up right away.

As the artist experiments with hairstyle and dress, notice how swiftly the character grows up. At first a young girl, she soon takes on a more mature appearance – the wide eyes narrow, the expression becomes sterner. Although the bow in the hair and ribbons and frills are kept in the final design, the entire stance has shifted. She now exudes confidence and calculation. This is achieved through body posture and the tilt of the head rather than any modification of the basic drawing style.

The costume gets more daring and the physique adult, until we have a dark and beautiful gothic woman (see opposite). Sexy qualities don't always have to do with appearance. They can arise from actions or personality.

The addition of a single accessory – such as a simple fan – can sometimes make all the difference.

Even when working in black and white, imagine what the colour scheme might be – it helps convey mood and personality. Wing Yun Man explains that the 'Red eyes make her look sinister, yet the large black bow and long purple doll-like hair suggest an underlying innocence.'

'I use a 01 black fineliner to outline the entire picture,' says Wing. 'Try to keep the inked lines neat, clean and smooth. This makes it easier if you decide to colour your image. Once inked, I scan it into the computer so it can be coloured digitally.'

Keep in mind that the end product here is a pin-up or colour illustration, rather than a Manga page. Producing an artwork like this – featuring your own character, in the style of your choosing – may be useful for the cover image of your comic, or as a promotional piece to advertise it (or yourself).

'This ends the process of creating a dark *bishōjo* character. I hope this helps inspire you in the creation of your own characters.' – Wing

DRAWING THE HEAD

Meanwhile, we are still modifying the designs of the *Warpath* characters in preparation for their appearance in the Manga sequence. To do this, we will construct the heads using the same basic shapes as shown earlier in the book. Work alongside this, doing the same with your own character designs.

Try to keep the features open and simple. For some reason, you can add as many lines as you like to a male character and get away with it, but not to a female. This may seem sexist, but unfortunately in comics it's true all the same.

Consider profile ('side on') and other views. You will need to figure out how they look from any angle. Some artists create a small head or figurine of their character in clay or similar material – to observe the play of light and shadow across it. After you have worked on the face and hair you will have your character ready for action. The larger it is in any comic panel the more detail – but the basic construction is the same.

DRAWING HEADS

When you are ready, use the blank heads on the opposite page to model characters to your own design. You may wish to draw them in a more typical Manga style – *shojo*, *shonen* or even *chibi*. Pencil first. Erase and redraw as many times as you need. When you think you have it right, try inking your heads.

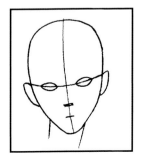

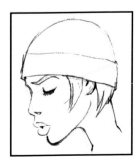

Using the 'blank' heads (bottom two rows), try making up your own characters. If you prefer, you may copy the heads on the top row into the second row – but make the third row your own. In the last set of three heads, consider drawing a character completely different from the set you just drew. If it was a male character before, try a female character. If it had a thin face before, try one with a fuller face – and so on. Practise by going over the blue-line images more than once, or drawing some of your own. Create a larger version. Change character, style, head shape, expression or any of the facial features as you like. Try different distances between ears, eyes and noses. Explore more angles. Then finish the drawings in ink.

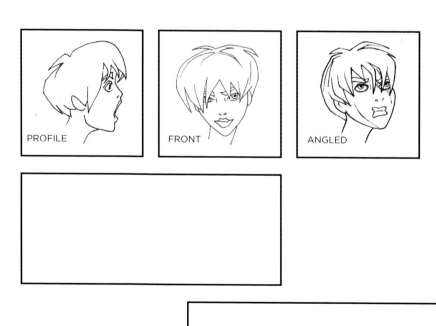

PROFILE

FRONT

ANGLED

DIFFERENT FOLKS

So far we've drawn heads and basic bodies – but your characters, according to who they are and what they do, will have different body shapes. They may be heroes, villains, superhuman, alien or ordinary folks. Whatever the character, you should fully explore their size and shape – it will affect how they move.

Large or small? Contrasts are effective. You can have great fun pitting a small and agile fighter against a lumbering giant. But what if the giant was swift too? (In Sumo wrestling, a clash of titans may be over in seconds.)

Just remember, ladies, just like gentlemen, come in all shapes and sizes!

BODY SHAPES

Different characters have different body shapes. This first example has long, thin limbs and moves lightly and gracefully – it could be a dancer; it could be female.

Feminise your figures by giving them a different body outline from that of your basic figure – bust, large or small, and hips generally wider than the male's.

Take the drawing to the next stage. Draw over the blue lines to fill the construction frame out. Then add the building blocks of the character's overall shape.

This character is immediately different from the first. It seems heavy and menacing. Even the construction frame has these qualities. The head is blocky and set low. The limbs are thicker, the body wider. How large is this character, do you think, compared to the first?

Take this drawing to the next stage – add in detail, clothing and anything else you want to add to the character design. Does it hold a weapon? Does it have wings? It's up to you.

DO YOU KUNG-FU?

Here's a *shonen*-style action shot. Even the most detailed, action-packed page of Manga begins as a simple sketch.

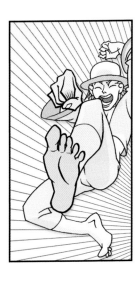

Construct your character from scratch and you will gain a better understanding of how they move. They will also look more convincing. To do this, you must build up the drawing in stages. Draw directly on top of the construction images on the opposite page – in lead pencil first. You may copy the main image here if you wish. Even better – redesign the figure to make it into your own character.

Step 1: Start with a very basic frame or 'skeleton' – nothing more than a stick figure. This is the most important part of your action drawing – all the movement is established here. Note the curve and direction of the various parts of the body – the position of each of the limbs, even the head, in relation to one another.

Step 2: Your figurine comes in useful here. Add the building blocks of the body to the frame. They are basic geometric shapes – columns, globes, a square. Overlapping shapes help convey what is coming forward out of the page and what is going back (a little 'x-ray' vision is required). Pay more attention to detail that appears in the foreground.

Step 3: Next, add the facial features. The addition of clothes and hair, as well as any other props, may help to emphasise the action (in this example, the flared sleeves trail behind). Once you have fully pencilled in your character, it is ready for inking. Stylise the ink lines however you like – sharp or soft, thick or thin – but keep things open and simple.

TURN TO THE NEXT SPREAD TO CONTINUE DRAWING CHARACTERS IN DIFFERENT ACTION POSES.

FIGURES IN MOTION

Your turn. Construct the action figures as shown on the preceding pages. Decide what you think each of them is doing. Give them different body shapes: fat or slim, male or female, naked or extravagantly costumed. Figure out the possible combinations, and try at least one of each. Add the basic building blocks with pencil and then start to ink them in.

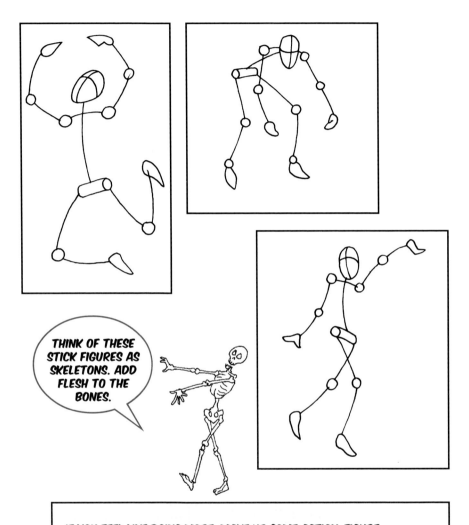

THINK OF THESE STICK FIGURES AS SKELETONS. ADD FLESH TO THE BONES.

IF YOU FEEL LIKE DOING MORE, MAKE UP SOME ACTION-FIGURE SKELETONS OF YOUR OWN, AND THEN BUILD UP YOUR FINISHED CHARACTERS FROM THERE.

THE FEMALE FIGHTER
by Maguro LiLi

Before creating any human character, understanding the human form is essential. This step-by-step will take you through the process of creating a fantasy character starting with a basic structure as the basis of your artwork.

Step 1: Here I will draw a female fighting character. A 'pose' plays an important role in bringing your character to life, so I will use a fighting stance. Always start your design with a stick person as a guide. It works every time.

Step 2: I started with a stick person, and then drew the character's figure out, almost like applying muscles and skin. Remember that a female and a male character have different shapes and body sizes. Since this is a female character, let's keep this body shape feminine.

Step 3: Here is where the design process begins. Remember to have a concept in mind before starting this bit. As for this character, I used a futuristic concept. At the same time I wanted a fighter, so that made it a futuristic fighter. Once you've decided on this, apply any clothing that you want to the figure.

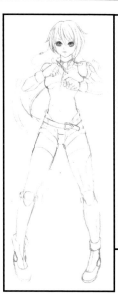

Step 4: Remember to stick with the concept. I wanted a futuristic fighter character so a tight suit with some gadgets might enhance this. Do not let your design overwhelm your character. For example creating gigantic armour or silk wraps doesn't make any sense – it will only restrict your character, especially if they are a fighter.

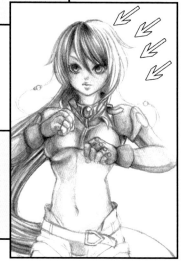

Step 5: Next it's time to render the character. Always set the lighting direction before shading as a guide to where the shadow will be applied.

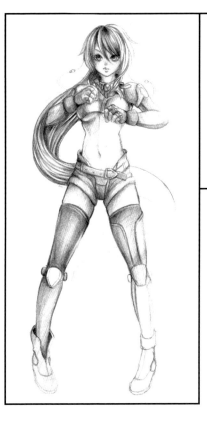

Step 6: Take the time to understand each material you are shading. Different materials reflect light in different ways. For example, a metallic object is more reflective than the same object made of rubber.

Step 7: We are almost there, now we have the shading and design. For the final touch-up I applied the darkest tones and cleared up any mess such as extra strokes and dirty marks.

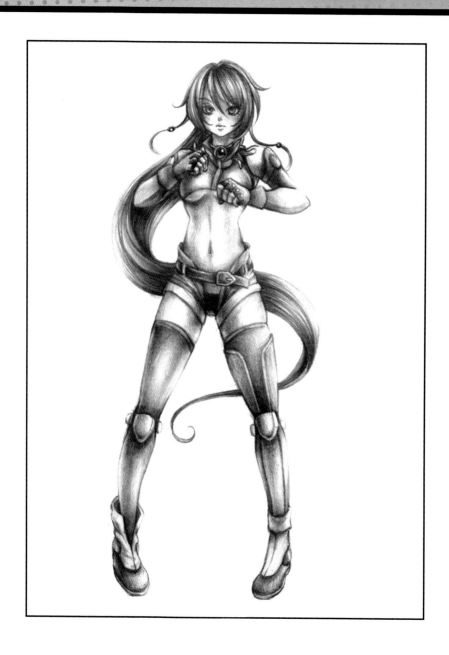

CONSTRUCTING MECHA

Want to draw robots? Earlier in the book we explored the basic physics of the human form, breaking it down into geometric shapes. Constructing your own *mecha* involves these same basic principles, but with mechanical parts. If you need some inspiration, pick up some books on engineering from your local library so that you can study the workings of machines. Japanese robots are cool because they look like they might actually work. Manga are full of convincing robot characters, like the ones below.

Some technical images of mechanical parts. A *Duden Pictoral Dictionary* is a good reference source for these kinds of images. Books on product design, production design for movies and car manuals may also provide inspiration. Copying and adapting real mechanisms beats copying other artists' Manga robots.

THE WORD FOR THIS MANGA GENRE IS FROM ENGLISH! *MECHA*, SHORT FOR 'MECHANICAL'.

Sleek and dangerous or funky, big and clunky – just a few Manga and anime robot designs.

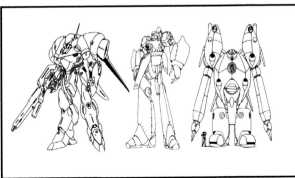

Robots are really big in Japan. Adapted from Manga for television and film, into collectible toys, and back again. Check out this cool robot-versus-monster movie poster for *Mazinger Z vs. Debiruman* ('Devilman'), a comic based on the toy line based on the comic *Mobile Suit Gundam*.

MECHA STYLES

Traditional *mecha* are big and chunky, almost like vintage cars. Think fins, chrome bumpers and large, smooth shapes of gleaming metal placed at sharp angles to each other. *Mecha*'s giant robots are constructed from many components, are often designed to walk upright like a human and are sometimes also able to transform into vehicles or giant weapons.

Shinohara AV-98 (Alphonse) from Patlabor

Are you ready for giant *mecha* Kittylips (see left)? Successive generations of Craig Conlan's robot character work their way through *mecha*'s most fashionable wardrobe designs – all polished chrome finish and burnished steel!

The American cartoonist Brian Ralph shows his love of Manga and *mecha* in these trade advertisements (right) featuring his own fun version of 'man in a rubber suit' style heroics, *Fireball*! You too can arrive at your own original design solutions.

THE FUTURE OF MECHA

Science is constantly pushing back the frontiers of possibility. *Mecha* first appeared in the 1950s. Now, with the advent of nanotechnology, there is no real reason for these giant robots to look the same way. They might come to look less like *mecha* as we know them, and more like – as one leading nanotechnologist describes it – 'grey goo'. Alternatively, they may be too small for the human eye to see! Try to imagine for yourself what the robots of the future might look like.

A FEW WORDS OF ADVICE

It's okay to copy other characters when you are practising Manga. You can learn plenty from copying many different kinds of imagery but, ultimately, becoming a Manga artist is about finding a style that suits you.

Many of the character examples in this book have been created so that you can practise the many Manga styles available to you. These exercises should help you develop your own unique Manga characters. There is nothing wrong with drawing inspiration from other Manga artists, but it's probably wise not to copy their characters exactly, especially if you want to print and circulate copies of your Manga strip. This would be an infringement of their copyright. So, when it comes to making your own Manga, try to make it in your own style, and with your own set of characters. Then it will truly be unique to you. You can show it wherever and to whomever you like and declare, with pride, 'I made this. It's all my own work!'

You may have come into this book with a fairly fixed idea about the sort of Manga you want to draw – the Manga you already know, read and love. The chances are these will be *shonen* or *shojo* of some description, or 'typical' Manga. Although 'typical' Manga may look simple, it can be quite difficult to recreate. This is a single, narrow definition of Manga, one with quite formal rules and a set look. As we have already explained, this is just one of the many Manga styles available to you. If this style doesn't come naturally to you, remember that authentic Manga comes in many different forms. The material we see translated in the West doesn't even begin to show all of the permutations.

The examples have introduced you to a number of different styles, but these just represent a tiny fraction of the range of Manga that's out there. There are no rules and no set look that makes one person's drawing more 'Manga' than the next. Keep exploring in whatever direction works for you.

If you are having any problems finding inspiration, this page will help you. Designing and drawing your own characters should play to your own strengths and natural style. Base them and your storyline around the things you are familiar with – your favourite subjects, hobbies, passions or enthusiasms.

- What are you good at drawing?
- What do you want to draw?
- What would you like to be better at drawing?

There should be a story you are aching to tell, and at least something of yourself in it (even if it isn't obvious).

No clues yet? Then ask yourself:
- What annoys you?
- What amuses you?
- What confuses you?
- What worries you?
- What fascinates you?
- What scares you?

Still stuck for a character story? Inspiration may be found from many sources. Consider some of the below:

- The elements – earth, air, fire and water
- The signs of the Zodiac
- Totem animals
- Legends and folklore
- Your own heritage – cultural or family history
- News items
- Music and lyrics
- Dreams
- Real-life experiences

Try each and every one. Talk to people. Bounce ideas around. Brainstorm. Sketch.

CHAPTER 9

SHOWING EMOTION

IN MANGA, EMOTIONS ARE EXAGGERATED. NOT ONLY MUST YOUR CHARACTER EXPERIENCE EMOTIONS, BUT THEY NEED TO COMMUNICATE THEM TO THE READER, TOO.

FACIAL EXPRESSION

Manga is all about mood. It is not enough for any character to just experience an emotion – they have to express it. In this respect Manga is more theatrical than cinematic – everything is exaggerated for dramatic effect. The audience's sympathies must be engaged.

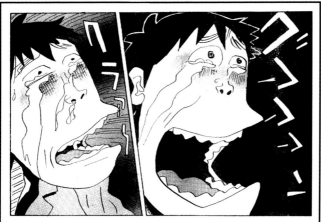

Zokubutsuou 'King of the Moneymen'

It isn't enough to feel sad. You must feel the saddest you have ever felt. Impossibly, gut-wrenchingly sad. So sad your face is made of elastic.

There is of course room for subtlety and calm moments, but if emotion is in the air, Manga characters should appear as if they are on the verge of meltdown, or going to explode at any second.

COOL

BLITHE

HUH!

JOY

BLUBBING

BLUBBING (INKED)

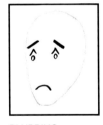

MOODY

MOODY (INKED)

MAKING FACES

Even the most complex of facial expressions can be broken down into very simple mouth and eye movements.

EYES

Manga eyes are filled with liquid shine to make them seem even more emotional (see page 43). Raise the top eyelids high above the pupils to express shock or surprise, or cut them midway across to look cool.

EYEBROWS

The eyebrows work like bars on a gate: raised eyebrows seem open and friendly, whereas lowered eyebrows appear closed and unfriendly. If you draw one eyebrow up and one down, it conveys doubt. Alternatively, level eyebrows are non-committal or cool.

MOUTH

In Manga the mouth may twist into almost any shape, becoming impossibly large or unfeasibly small. You can also distort the mouth to create a variety of emotions – a squiggle implies confusion, a downturned mouth conveys sadness, a shortened line, ill temper, an 'o'-shape expresses surprise, and an upward-turned mouth, happiness.

CARTOON EXAGGERATION

Hokusai originally coined the term 'Manga' for his 'rambling images' or 'irresponsible pictures'. Other interpretations include 'cartoon image' or 'caricature'. As explained (page 114), faces may undergo quite cartoony transformations even in the middle of more serious or naturalistic styles of Manga.

When the clear intent is humour, which is most commonly found in combination with *chibi* or super-deformed style, there's no limit to what's possible.

Study these expressive views of the character Hiragiku or 'Crazy Daisy', a multilingual vigilante and relatively psychotic little girl with a fondness for handling large and explosive weaponry. The artist, Wing Yun Man, has managed to convey a number of emotions using a very basic technique.

Relatively simple cartoon distortions like this are the basis for almost any facial expression, whatever the final style of drawing might be, so it's worth getting busy with your pencil and exploring every possibility in this simplified form.

ABSTRACT EXPRESSIONISM

Swiss graffiti artists the Mentary Brothers have taken one hairdo and an obvious fondness for Manga and come up with about a million departures on this same theme. This page features a selection of the best. These images clearly demonstrate that there are no limits to one's imagination. The exaggeration of a facial expression can encompass metaphor, abstraction or just plain silliness. In this context these images are just doodles, but imagine how, when or why you might make use of such sudden substitutions within a storyline. Manga are comics, and in comics anything is possible – anything can sprout a face and a face can become almost anything else. Anything goes!

CHAPTER 10

TELLING YOUR STORY

YOU'VE WORKED ON YOUR CHARACTER, THEIR MOODS AND EMOTIONS, THE ENVIRONMENT... NOW PUT EVERYTHING YOU KNOW TOGETHER TO MAKE A STORY!

TELLING YOUR STORY

The main event. By the time you have reached the end of this project section, you should have created your own comic strip. The following pages will show you how to draw an eight-page Manga sequence.

Treat the eight-page sequence as a printable document. Imagine that your goal is to print and circulate copies among friends and family and get their feedback. The first thing to decide is whether you want to include a front cover design as one of your eight pages. This might make sense if your aim is to create a self-contained short story – complete in this many pages (or less). If so, the cover would be page 1 in the sequence, leaving seven pages in which to tell your story. The sequence we will be creating here as a working example is a scene taken from a longer story, so all eight pages will be story pages. If you decide not to start with a front cover, you can always add one later on.

Think of the pages in terms of spreads – beginning with a right-hand page and ending with a left. The reasons for this will become clear later, when we prepare to print the story. Although you will be drawing the pages on individual sheets of paper, you must keep in mind which pages will appear opposite each other. This is particularly important if you ever plan to feature a double-page spread, where single images split across two pages (see opposite). You need to plan for those two pages to appear together in order for it to work.

KEEPING THINGS SIMPLE

In telling your story, don't be over-ambitious – avoid galaxy-spanning epics or complicated sequences. A single scene with one or two main characters should be enough. Eight pages is nothing more than a blink of an eye in Manga terms – a minute or two's reading. At most you will have space to tell only a very simple short story. Or, you could show an excerpt from a larger storyline that you have in mind. (Don't feel you have to start at the beginning – go straight to the part of your story you want to draw the most. You can put it in context later.) Try to make sure your story has some form of resolution within its allotted span: a beginning, middle and end.

Authentic Manga are usually hundreds, if not thousands, of pages long, but you have to start somewhere. For now, eight pages is a manageable goal – you might be surprised at just how much work even that many pages involves!

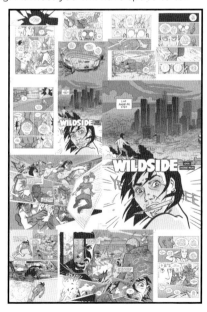

THUMBNAILS

When thinking up your Manga story, sketch out lots of thumbnails (simple little drawings and jotted notes for dialogue and such). All comic artists do them – it's the way they think 'out loud' on paper. It is best to experiment and find what works during these early stages. Every hour spent here saves days being wasted later on.

LOOK BEFORE YOU LEAP

Resist the urge to jump right in and start drawing your story straight off – few people can get away with it. Each panel of a Manga, each page, links one to the next in order to do its job and tell a story – it is much more than a series of cool-looking illustrations. You may get the drawing part right but not have left enough room for the feet or head, or details may be facing the wrong way for your next image, and so on. Over the following pages we will look at how to apply the compositional techniques of panel layout and page layout in the construction of real, working story pages.

Here are early sketches for some story material before it was rethought in Manga terms. This two-page thumbnail sequence – laid out in the style of an average Western comic strip - includes the main part of a scene that will later be expanded across eight pages of Manga! It will serve to show just how differently Manga are paced. Not necessarily a more leisurely pace – just different.

You may not be able to tell much from these scribblings. Thumbnails are very personal – they are production drawings, not necessarily intended for others to understand. As long as you can understand your own thumbnails, that's what counts!

To help you decipher what I had planned, here are copies of original rough layouts based on those same thumbnails. These are much reduced in scale – they were drawn at the same size as the final art pages were going to be. As you can see, the pages don't entirely work. The action is too compressed to make a good Manga.

PANELS IN ACTION

Take your storyline and break it down into a sequence of events. Work your way forwards moment by moment, in a logical order. Don't worry about page layout yet. Work things out one panel at a time, from panel to panel – use a line of panels one after the other. Think of what is occurring and how to show it happening clearly, step by step. While you are doing this, have your mind on the dynamics of storytelling. Consider whether anyone is speaking, and if so, whether or not the speaker is in shot. Generally they need to be – at least at first, to establish who it is that is talking. What are the reactions of your characters? What are they doing, and how are they doing it? Where is your viewpoint as events unfold? Do you need to see certain things from more than one angle? As the director of the action you need to figure out when to zoom in, zoom out and cut away.

Some events happen fast (fewer panels) – others slowly (more panels). Try to keep the pace consistent with what is happening in the story, but also vary it to keep it interesting. Go from fast to slow and back again, or the other way around. Looking at your panel sketches, you will see where you need to add a panel or where you can take one away. Lose anything you don't need. Tell the whole story or scene in this way, beginning to end.

Now check through the panels and revise the order, view or direction as appropriate. Happy with the flow of it? Then count them up – how many panels do you have? Divide that number by the number of pages you have to fill – in this case seven or eight. If it works out at more than 56 panels – an average of six to seven panels a page – you will have to lose some. Any less than 48? Great. You're laughing.

Next, still working on thumbnails, you need to make up page units out of your panel sequence. You may end up drawing the same directions to yourself many times over in order to get them right, which is why they are no more than scribbles – indications for later drawings, not drawings by themselves. Here are the first four pages of thumbnails.

Look at the arrangement of panels on the page – their size and shape. No one page should be too full or too empty.

Each page should have its own focus, logic and reason. A variety of shots (or views) lends visual interest.

If anything doesn't work, change it. Here the last two panels are combined into one – there was too much going on.

Always think about pacing. Here the artist's jotted notes suggest that the action in panels 3 and 6/7 should go faster.

PAPER FOR FINAL LAYOUTS

Choose the right paper for the job. Ordinary paper is what you are probably used to – the same used for sketchpads, documents and in most photocopiers and printers. This paper is suitable, but even then it comes in different weights and some makes have a different finish (or surface) than others. Make sure it is at least 50 lb–80 lb or so would be better. Some ink styles take better on a slightly rough paper surface (one with 'tooth'), but you will probably find smooth paper more suitable. You may find that one side of the paper is smoother than the other. Close your eyes and run your fingertips over the surface if you aren't sure, and try to stick to using the same side each time.

LAYOUT

A pad of layout paper is almost essential. It's twice as thin as ordinary paper, just as strong, but also twice the price. It's great stuff for working drawings such as page layouts, because you can see through it and trace over another drawing laid underneath – making copying and corrections easier.

ART PAPER

The pages of your actual artwork need to be on something substantial, to withstand wear and tear. If the surface breaks down when you use an eraser, it's no good. It has to take pencil well, and ink too. A heavier-weight paper is suitable. Bristol board is a widely recommended industry standard. You can buy it in pads as well as single sheets.

Using layout paper or trace allows you to rework designs easily or add to them in layers as you go along.

PAGE LAYOUTS

With the thumbnails done, you are ready to lay out your pages. Almost everybody has their own way of doing this – you will soon find what suits your individual temperament and skills. You may work directly onto the paper that will become your final artwork. Or you may find it useful to produce another in-between stage of rough layouts, which you then trace over to form the basis of your artwork pages.

DIFFERENT PAGE SIZES

Manga formats have relatively small pages – good reason not to overload them with too much detail. Artwork is produced at a larger size then reduced down when it is printed. This tightens up the images nicely and also makes them easier to draw – you would probably find that working at actual size cramps your style. Everybody will have their own preferred size (or 'scale') at which they are most comfortable working. As long as pages remain in the same proportion when they are reproduced, they can be produced at any size.

ART
33% UP

LAYOUT /
PRINT

ART

DOWN
75%
PRINT

ARTWORK IS USUALLY AT LEAST ONE THIRD UP FROM PRINTED PAGE SIZE (33% LARGER, OR 133% IF YOU SEE THE FINAL SIZE AS 100%) TO GET THIRD-UP ARTWORK BACK DOWN TO PRINT SIZE, REDUCE IT TO 75% OF ITS LARGER SIZE.

WORKING METHODS

Some artists sketch their layouts lightly in blue pencil straight onto their artwork pages.

Alternatively, you can produce separate rough page layouts. If you produce them at the same size as the printed pages, you will have a clearer idea of how everything fits together and how it should finally appear. Once you are satisfied that they work, take these layouts and enlarge them on a photocopier to a size at which you are more comfortable drawing. If you have a computer, you might scan and print out your layouts at a larger size, but ink is expensive, and the size of your scanner or printer will limit the size of your final artwork.

TRACING OFF

Use a lightbox to trace enlarged ('blown-up') thumbnail layouts, or ink/amend your pencils onto a new sheet of paper.

Step 1: Place the first sheet (to be traced) beneath a blank sheet of paper. Use masking tape to fix.

Step 2: The light shines through the paper, allowing you to see the detail of the image to be traced.

Just as it sounds, a lightbox is a box with a light inside it, covered over with a sheet of pearl-frosted glass (to reduce the glare). These are extremely useful, especially at a larger size – legal (A3) would do, but tabloid (A2) is better - but are also extremely expensive to buy for what they are. If you are good with your hands, or have a relative who is handy at carpentry, a do-it-yourself homemade lightbox works just as well. Use fluorescent strip bulbs – you want light but not heat. Two bulbs side by side is best for even lighting.

No lightbox? You could tape the sheet to be copied to a window with a blank sheet over the top for much the same effect (in daylight hours!). It's a less comfortable way of working, and no good if your windows are dirty!

LETTERING

When designing the layout of both panels and pages, it is worth keeping to the following basic lettering principles. They may seem obvious, but in the excitement of drawing pages they are often forgotten. Whenever you are positioning lettering, have this spread open beside you as a constant reminder.

Decide where to place your speech balloons at the layout stage, before you do any drawing. There is no point drawing in areas that will eventually be covered over! Use lettering as well as panel composition to lead the eye where you want it to go, and in the order you want, across each page.

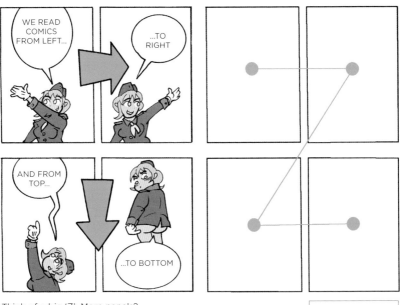

Think of a big 'Z'. More panels? More Zs.

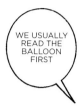

WE USUALLY READ THE BALLOON FIRST

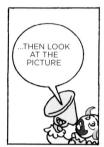

...THEN LOOK AT THE PICTURE

BALLOONS ARE HARDER TO READ IF THEY'RE >UNGK< CROWDED!

WRITE (OR TYPE) YOUR WORDS FIRST

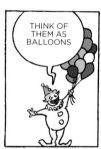

THINK OF THEM AS BALLOONS

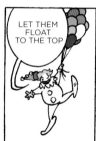

LET THEM FLOAT TO THE TOP

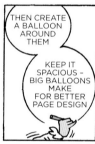

THEN CREATE A BALLOON AROUND THEM

KEEP IT SPACIOUS – BIG BALLOONS MAKE FOR BETTER PAGE DESIGN

DRAW A 'SPIKE' TOWARD WHOEVER IS SPEAKING

親を親とも思わん奴は

I AM CONFUSED

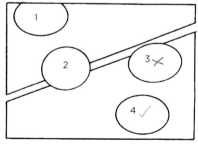

1

2

3 ✗

4 ✓

Japanese word balloons go like this – vertically! – as well as right to left. Relettering a translated Manga is no simple task!

On pages with angled layouts, make sure the balloons meant to be read first appear higher up the page than those following.

READING ORDER

The reading order of your layouts should be clear and easy to follow, even for somebody who is not used to reading comics. Your goal is to invite readers. Follow the logic of our learned reading order – left to right, top to bottom.

If readers still say 'I don't know what order I should read it in', then at least you'll know the fault isn't yours – they are showing a deliberate disinterest. Friends, parents or partners should be supportive of your efforts and give you constructive criticism.

Have your character sketches around you as a constant reference. Wildside arrives in Angie's tiny underground den. Two examples of 'exploded moments' in time – panels 1–4 being one, 5–8 another (all of their looking around occurs during the dialogue). Panel 5 is a close-up of Angie's right eye, looking back towards where Wildside stands, and may need to be made clearer. Eyes may need to be seen through hair – a cheat on representational reality. Fractured layout stops any feeling of forward motion and emphasises their close quarters. Perspectives are estimated, and in panel 8 deliberately exaggerated, but otherwise they need to be ruled at the pencil stage. We should be wondering 'What's she doing in panel 1?'

Wildside misinterprets Angie's offer. In panel 1, he removes his vest so fast it is virtually subliminal.

In panel 2, he climbs onto the bed and slips into Mexican Spanish, his own language of intimacy. The artist cuts Angie's direction across his – and against the reading order – to emphasise contrary action. Panel 4 is a zoom in from panel 3, to look over her shoulder (Wildside's viewpoint).

Note how the artist breaks the floating balloon rule in panel 5, but gets away with it because he is at the end of a tier. In timing, the artist uses the drip (panel 6) as a pause to emphasise Wildside's non-reaction (in contrast to Angie's). It interrupts a second zoom, between panels 5 and 7. Panel 7 needs to shift right a bit – sketch layouts are a useful safety net, allowing for such changes to be made.

PENCIL YOUR PAGES

Take your layouts and enlarge them on a photocopier to your 'working size'. Select a size you will be comfortable working at, especially when inking. But before you ink, you will need to pencil your pages. Working size is usually at least a third larger than the final size at which the artwork will be printed. Manga formats are quite small, so in the example opposite the layouts have been enlarged (originally drawn at print size) by 150%. They look the same size in the example opposite because they have been shrunk down again to fit the printed page, but the originals are larger! The actual dimensions of these pencil pages are 210 x 324 mm (8^1/$_4$ x 12^3/$_4$ in). The size at which you are most comfortable working with may well be different – larger again, or smaller. This is fine, as long as the pages are at the same height-to-width proportions as when they are printed.

These layouts have been drawn in ordinary pencil so that they can be photocopied and enlarged. The enlarged layouts were then traced onto art boards, ready for finished pencils and inks. It's up to you what pencils you use to sketch your layouts. In this example a non-repro blue pencil is used, so that hours aren't wasted erasing once the pages are inked. Non-repro blue is quite light, however, and you may find it more difficult to see what you are doing. Go back to ordinary lead pencil if you want, but remember to erase it after inking. Make sure you rub lightly, as some of the ink comes away too and you end up with less-solid blacks.

The page overleaf continues from the previous one. In this retrograde future bullets are scarce. This becomes apparent when Wildside refers to Angie's 'secret weapon' as a club. He holds it like one too (see panel 1). Panel 2 zooms in on Angie's face – her expression says 'I'll show you!' She then reveals that ammo clips are a part of her stash. Emotive speedlines have not been used to highlight the underwhelming revealing of the gun (page 3, panel 4), but they are used for the ammunition, as it has more significance. They are also used for Wildside's subsequent reaction (in a low-angle shot in panel 5), in effect saying 'Now THAT's impressive'. Note the way pacing is controlled by panel size and shape – panels 2 and 3, plus 6 and 7, are 'quick'. Strong directional movement or shape also helps speed them up. Panel 3's triangular shape emphasises the upwards jerk of Angie's arm and the cloth she holds – set up by their inclusion in panel 1. Sound effects also serve to emphasise events. You should keep details down to the bare minimum in such quick panels. Note that the artist stays with Wildside from panels 5 to 7 – Angie is no longer in view. This too speeds up the action. The reason for this is clear on the next page.

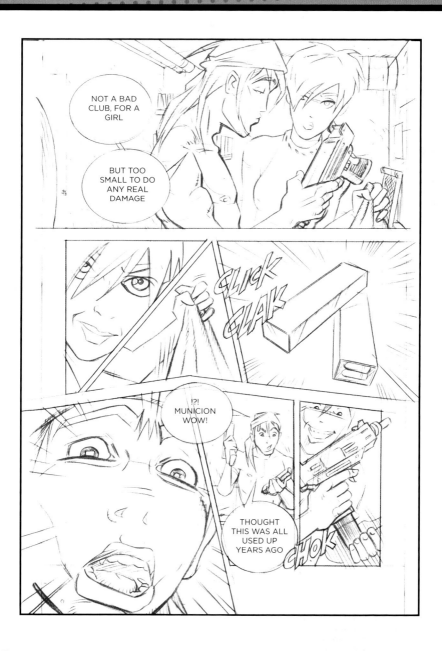

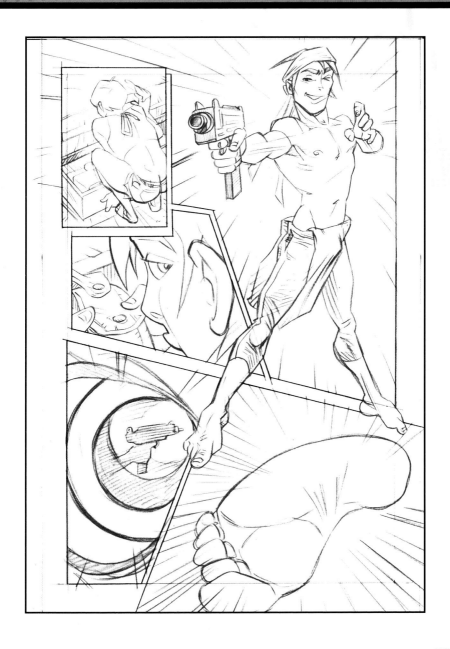

Like a kid with a new toy, Wildside has loaded a clip and is (probably) about to fire the gun (see previous page). Angie meanwhile has turned away to gather more supplies (another reason for not showing her at the end of the preceding page). Panels 1 and 2 are in effect inset to the main action of panel 3 (the focus of the page) – the borders of panel 1 even stray slightly outside the live art area, as if to signify 'meanwhile'. Much of the language of comics is subliminal – the reader is not intended to consciously notice these storytelling devices, but their effect should be felt (or instinctively 'read') all the same. Likewise, the chosen view of Angie explicitly states her back is turned – and a zoom-in/close-up to her ear in panel 3 hints that she turns her head because she hears something happening behind her.

What happens next is so fast we don't even see it (yet).

This page was laid out a few times, reversing the reading order of elements this way and that to speed up events as quickly as possible, while still retaining some kind of spatial logic (the awareness of where things are in relation to one another).

The close-up on Angie's widened eye is almost abstract, and only works as a continuation of the zoom from panels 1 to 2 (to 4). The angle also had to be matched. Only at layout stage was the decision made to cut all detail but the flying foot in panel 5.

Try to keep your pencil pages clean. Use the layout stage to work out any atmospheric tonework or shading and then you can confine your pencil pages to simple linework. If you were preparing your work for someone else to ink, or as a first-timer, you might need to figure out (and show) which lines should be thick and which thin. An example of this can be seen on the previous spread. If you feel quite relaxed about this, it's enough to picture how it might work in your head and leave line thickness until the inking stage.

To keep from loading the page with lots of pencil shading (which might smudge or otherwise confuse) many artists use a cross to indicate the areas they want to appear solid black. You may have spotted X's in the page border areas of previous examples. These have been marked up on the layouts in blue, to show you clearly where the panel areas fall. The plan is for them to end up as areas of black. Most of the story takes place above ground, and black panel borders will help make these underground sequences immediately distinct.

This is a risky piece of storytelling – deliberately not showing the main action – but it works well here. Check with a couple of test readers to make sure events read as you intend.

The only problem now is that both characters' feet are bare - the foot must be understood as Angie's. Wildside has darker skin, so the addition of tones could help make this distinction more clear. If it doesn't, one of them may have to be given footwear of some kind - as a late development, Angie could be given a foot bandage! This would need to be added onto all of the previous pages for continuity. An arm sash given to Wildside got in the way in one scene, and was subsequently deleted. You will find such amendments are sometimes necessary.

INKING

The very first thing to do is letter your balloons and then ink these in along with the panel borders (see opposite). This feels very satisfying – like running laps around the edges of your playing field – defining the strict limits of the panel areas you are about to fill. You are making that final preparation to commit your story to detail. If you use thick lines in your art, a thinner border line is best, but if you use thin lines in your artwork, a border line with thicker lines is preferable.

The word balloons featured on the page examples within this book have been typeset (computer lettered) for purposes of translation. You can hand-letter your pages, but this is relatively unusual. These days most professional comic book lettering is done by computer. There are many fonts (or typefaces – that is, styles of lettering) and lettering programs available that are relatively inexpensive and easy to master. If you are lettering by computer, plan where the lettering will go (draw it on the layouts), but rule your panel borders as if there were none there. You will drop it in over the top of your artwork later.

OUTLINES FIRST

Define all the major shapes with your ink first. Try to maintain a confident line – don't scratch, feather or dab at the page. The less confident you feel about inking the more defined your pencilwork must be, so that you know exactly where to draw your ink lines.

Ink feels very different from pencil. Pencil produces subtle shades of grey, whereas on an inked page the art is either black (ink) or white (paper). Ink takes no prisoners. Don't keep adding more lines if it doesn't look right. Stop and think, study and experiment and test on a separate sheet or a photocopy of your page. You may have to do quite a bit of practise work before inking your actual pencilwork, and more before eventually getting something you are happy with.

This doesn't suit every style, but sometimes a thicker line around the outside of each figure or object, and thinner line detail within, is a useful way of keeping images clear and defined.

FOCUS

Just as every page has a point of focus, so does each panel. Try to identify what that focus is before inking each one. More careful detail (and often thinner linework) in these spots attracts attention, leading the eye toward them. Character faces are a common point of focus, especially the eyes. At other times the point of focus may shift according to the primary subject of a panel. If a panel features blurs or speed or action lines, it's a good idea to draw these in first, because they often break up the outlines of objects.

Still moving the story along quicker than the eye can see, the gun hits the wall and falls to the floor, while Wildside – perceiving himself attacked – instinctively drops into a combat-ready crouch. Clipped fast-forward moments in close-up reinforce the speed of events and heighten the emotion. The compact view of Wildside in panel 2 is made clear by a zoom-out (panel 5), when all the aggression in his pose gets punctured. We don't need to see Angie pick up the gun between panels 3 and 4 to know that she has. Panel 4 – Angie's close-up, delivering most of the dialogue – is the prime focus of the page.

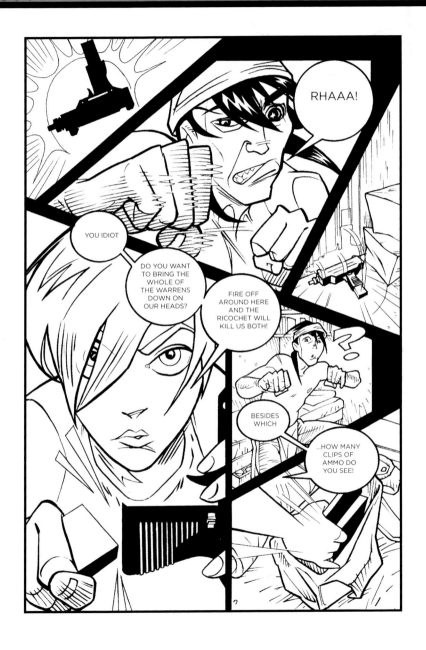

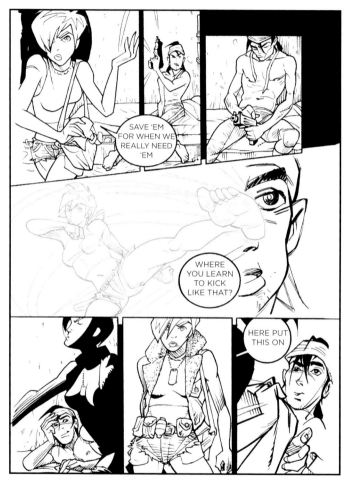

Panels 1 and 2 are a single panel, split in two – the 'shot' held across the toss of the gun between the two characters. Splitting the panel in two advances the time frame. It further suggests that the characters are linked, but also keeps them separate (in fact, Wildside and Angie have not shared a panel for many pages!). The symbolism within panel 3 should be obvious. In panel 4 we finally get to see the kick we missed on page 5, in Wildside's recollection (or mind's eye). To be completely correct Angie should be seen from a more distorted angle – but since the action was not seen at the time, it needs to be clear here.

FOREGROUND, MIDGROUND, BACKGROUND

When inking, think of these three things – foreground, midground and background. Foreground is what's closest to you in view. The outlines of shapes here will be thicker, and the contrast between thick and thin linework perhaps greater than anywhere else. The background contains more or less detail than in the foreground. Linework is often of a similar thickness with little contrast. Midground is the area in between. Take the top three panels opposite. Angie (panel 1) is foreground. The tossed gun travels through an otherwise empty midground. In panel 2 Wildside on the bed is effectively part of the background of panel 1. Panel 3 is really all midground, with a little foreground emphasis and background recession. The figure of Angie in panel 4, her leg foreshortened, comes from midground to foreground.

SHADOWS

How is your scene lit? Where is the light source? High or low contrast – are the shadows deep (spot lighting) or shallow (evenly lit)? Even in a scene in low-level light, as seen in the example opposite, a little shadow helps to solidify and ground figures and objects – the underside of a limb here, beneath a chin there. It lends weight and presence. Remember, this is 'dramatic lighting'. Cheat. Add shadow where it will be most effective, not where or how it would necessarily fall in reality. Use it to direct attention to specific parts of the image, or to create instant mood or changes in mood.

TEXTURE

Add touches of feathering to further define shapes or add 'grit'. These characters don't get to wash often, so in close-up flecks of dirt and tears to clothes have been added. Not too much though, or it distracts. Sometimes the addition of textural marks to a background pops a less detailed foreground element forward – at other times, the reverse will work better: detailed foreground, simple background. Equal levels of detail in both flattens your image out.

TONES

Tones are widely used in Manga, and add another level of polish to the pages. Used sparingly, they can help define objects, clarify images, enhance moods or add detail – or a little of all of these. Additional linework in the form of hatching and feathering is a type of tone – suggestive of areas neither black nor white but something in between. This effect has been used on Wildside's trousers, for instance, and the dirt and texture on the wall.

When covering larger areas, mechanical (dot-screen) tones produce a neater finish. There are various ways to think about the application of tones to your artwork, both compositional and narrative – according to the modelling of shapes, lighting effects, texture effects, shine and shadow and so on. Mix and match them according to the effect you want – but don't overdo it. Simple images work best.

For the last page of the sequence all of the panels are kept within the margins. The whole of your comic can be laid out in this way, or it could all go to bleed – or a combination of the two, as shown on previous spreads. If going to bleed, try to use it for a deliberate reason or effect. Study the rhythms of page composition throughout this example. Pay attention to whether a page is a right-hand or a left-hand page on a spread. On one side of each page the margin area will disappear into the spine or binding of a Manga book (see opposite), and the other may be unevenly cropped – so any detail outside of the live art area is at risk of being lost. This is why lettering and any significant part of an image must always appear within the inner margins. Tighter panel compositions and lots of close-ups add to a sense of claustrophobia. Apart from taking place deep underground, this scene has become emotionally claustrophobic.

Tones may be used to define the colour or shade of certain objects, such as a darker skin tone or an article of clothing.

Separate out areas of foreground, midground and background, applying tone to one or another of them.

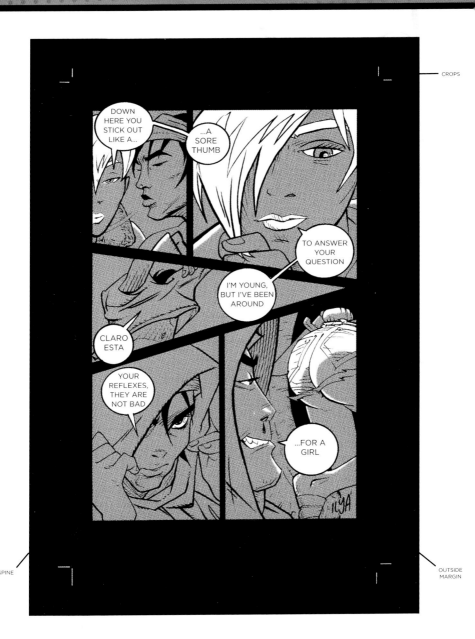

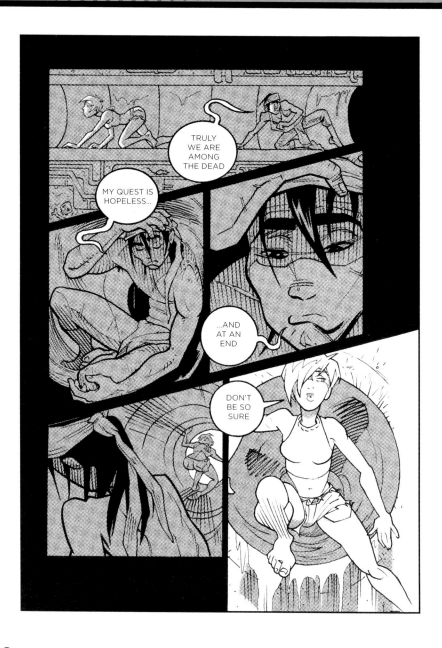

TONE ENVIRONMENT

Since this entire scene takes place underground, tone is used, instead of white, as a base 'colour', to suggest gloom or darkness. The details of the scene, otherwise blanketed in a uniform grey tone, are picked out in white. This is a fairly bland use of tone effects – Manga are usually much more subtle – but the intention here is to evoke the oppressive feeling of a low-level light environment. This would be in stark contrast to the customary look of the rest of the strip (not seen on these pages), taking place at street level – and in bright sunlight, where tones are minimal.

Here tones (or the areas of white in between) define a light source, throwing most of a scene into shadow.

Modelling can reinforce shape and add presence or weight.

TO DRAW YOUR MANGA IN THIS MANY STAGES – THUMBNAIL AFTER THUMBNAIL, TO COMPOSED PAGES, TO LAYOUTS, TO PENCILS, TO INKS, TO TONES – MAY SEEM TIRESOME, BUT HOPEFULLY YOU CAN SEE HOW CAREFUL PREPARATION MAKES FOR EFFECTIVE PAGES.

THIS APPROACH COMES HIGHLY RECOMMENDED, ESPECIALLY ON A NEW PROJECT WHEN YOU ARE NOT YET FAMILIAR WITH YOUR CHARACTERS OR THE STORYTELLING PROCESS.

You can draw in tone, to add extra detail and texture.

Here the sound effect lettering is picked out in tone.

ACTION IN PANELS

There is plenty going on in this short scene from *Warpath*, on a number of levels. Within the ongoing storyline, one of headlong action-adventure, it serves the necessary function of a rest stop. From her lair, Angie gathers supplies for the next leg of their journey. By the end of the sequence their physical appearance is changed from what it was at the start. Angie wears extra clothes and equipment, a 'utility belt' of sorts, which will come in useful later. Wildside's gangland style is disguised by a hooded cloak (seen partially on page 197). Between them they share the gun and ammunition (further reason to stick together). The depth and entire dynamic of their relationship has also developed.

Further undercurrent layers of meaning are psychologically acute. Angie's hidden strength has been revealed. Her mature quality of true leadership (brain and brawn) is expressed through her recognition of Wildside's potential and her surrender to it. She understands that her best chances of survival lie with him, but that in order to succeed he needs to feel empowered. At a low ebb, he needs a boost. She is willing to sacrifice her pride and let him lead, and quite literally gives him her power. (As we can see from the lift in Wildside's spirits by the end of the scene, Angie's ploy has succeeded - even at a cost to herself.)

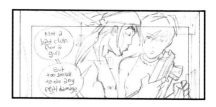

Here the gun itself is much more than a gun. In the story it is used as a symbol of trust – of power – but also of potency and virility. There is an undercurrent of unexpressed/suppressed attraction between the two characters. The gun as a sexual symbol brings this out into the open.

A subtext or hidden meaning such as this will often govern the overall shape of a scene, and is its function within any larger story. Storytelling decisions are centred upon it. As long as a *mangaka* is aware of what he or she is doing – and does it well – readers will sense it almost unconsciously, without anything having to be directly stated.

GEKIGA

The Japanese have a concept known as *gekiga*, 'drama imagest' – almost another way of saying 'graphic novel'. That, primarily, is what Manga are – novels in a comic-book format. They are of sufficient length and complexity to justify comparison – although it has to be said, as with any medium (novels, film, music), there's an awful lot of rubbish around as well as all the good stuff. Lazy film, TV and book critics often use 'comic book' as a term synonymous with simplistic or dumb. In truth, standards of comic book plot, script and storytelling are usually equal if not superior to the output of most every other medium – and the best of it, let alone the worst. This is the great open secret most comic book fans are in on.

In Manga a great deal of time, effort and imagination is put into the creation of entire worlds. Care and attention is lavished upon the portrayal of well-rounded, psychologically complex characters. After all, readers are meant to grow fond of them as they follow their adventures, to respond to everything that happens and be convinced of their particular brand of reality.

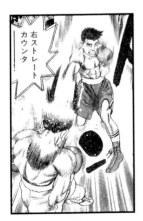

This example of *Gekiga* shows how movement lines and jagged edges around speech bubbles heightens drama in a scene.

What is wonderful about Manga is that it represents the comic language in its most natural, long form. Manga is 'director's cut'... Manga is 'extended play'... Manga is (at least) 'two for the price of one'. Working professionally on Western-style comic strips means forever cutting story material to fit a limited number of available pages – short stories six or eight pages in length, or monthly episodes of 24 pages or less. In storytelling terms, compared to the stripped-down and uptight page layouts of traditionally Western comics, Manga is luxury. Conversational scenes can be filled with incident and emotion. Attention can be paid to minutiae of character detail and body language. Given room to breathe and maneuver, action sequences come into their own and flow across as many pages as they need. The pace of Manga storytelling feels both instinctive and right.

SET SCRIPT

If you really have no clue what story to tell in your Manga, you should find a writing partner to collaborate with. In the meantime, here is a set plot/script exercise of sorts you can make use of. A simple, largely wordless situation for you to interpret as you like.

> A one-room mountain cabin. Snowstorm outside. Roaring fire in the fireplace. Two characters. One is thin and scrawny, the other huge by comparison. On the table in between them is a knife. All attention is on the knife.

Think how you will establish the known facts of the scenario. Begin with a shot of the mountain? The cabin? Begin with the knife, and open out from there? A slow build-up and a late revealing of the knife? Whose knife is it? Where did it come from? (You might place an empty sheath somewhere, or on someone.) Imagine the tense atmosphere. Show it. You might use the crackle and leap of the flames as symbolism – reflections of the fire in their eyes. Is anything cooking?

Jot down any images or panels in thumbnail as they occur to you, and then try to work out how the pages might come together. Set up the situation, and then in the last two to three pages try to resolve it. Think of an obvious outcome, and then try to avoid the obvious.

> **SKINNY:** Do as you would be done by.
>
> **SKINNY:** That's what they say isn't it, Clyde?
>
> **SKINNY:** You've let me down for the last time!
>
> Thin guy goes for the knife and sticks it in the giant guy's chest. Giant guy collapses forward into the light. As all the air escapes out of him, we realise it is an inflatable doll(!).

SPOILER WARNING

The preceding example is one of many possible solutions. See if you can come up with a suitably dramatic or equally radical resolution to the basic setup of your own design.

CONFIDENCE

Comics are great fun, but – like anything that requires real, hard work - you have to put the hours in. Long hours. Some folks compare making comics to films – but that's a bit too simple an argument. It's not like you're just the film director. You're also the lighting designer, casting agent, wardrobe, choreographer, script department, runner – and probably caterer, too!

Don't be easily discouraged. You may by now be looking at your first efforts and thinking they aren't very good. We'll let you in on a secret – no artist likes their own work, especially while they are struggling with it. It never matches what you can see in your mind, what you feel in your bones. You may be imagining great galaxy-spanning epics and it feels frustrating when you can't even finish one page of it you are happy with. The trick is to set smaller targets first.

If this first Manga didn't quite work out, make another. And another. Practise, practise, practise. The more you practise, the better you will get. Everybody always says that – because it's true! So – and this is important – **don't tear anything up and don't throw anything away**. Every mistake you make means you have learned something, and every drawing has a spark of inspiration in it that might ignite something even stronger later.

TRICKSTER

And another thing is – you can always fake it! The secret of good drawing is to have a confident line. Even when you are not sure of what you are drawing, if it is drawn with sufficient assurance (the appearance of confidence, whether or not you feel it), it will be convincing. And it helps if you have a genuine love of Manga. You have to love what you are doing, or at least the idea of it. You'll still have to work the hours, but the hours will fly by.

A DIFFERENT FINISH

You can circulate your Manga in a couple of ways. The first is to print up some copies and compile them into a mini-comic, or pamphlet. The best and most economical way of doing this is to photocopy your comic pages. The printed comic will be made up of two sheets of paper, printed on both sides – each sheet has a front and a back. Your pages, printed at Manga size, should fit two-up on each side of a sheet of photocopier paper.

PAGINATION

Preparing artwork for print involves pagination – working out the order the pages will appear. Taking your eight-page Manga sequence, you will need to lay it out as shown right, as a set of four spreads. As you can see, the order is different from how it looked on page 175. When the double-sided sheets have been printed you will fold them together, and at this point the pages fall into the correct reading order, 1 to 8. If you have more than eight pages, or less, the pagination is different again. You will need to work it out afresh.

Once it is printed and folded, the centre of each sheet will become the spine of your Manga. Reduce your artwork pages to the correct print size. You should then crop your pages using the crop markings (opposite), but only on the side that points toward the spine according to

SHEET ONE

8	1

front

7	2

back

SHEET TWO

6	3

front

4	5

back

the pagination. Here, it is the left-hand margin of the odd pages (1, 3, 5 and 7), and the right-hand on the evens (2, 4, 6 and 8).

Butt the cropped pages together in the order shown opposite and tape them together. These are your 'masters' from which you print your comic – a front and a back sheet for each of the two printed sheets.

Make as many copies as you realistically think you need – you can always make more later if you need to. Print separate covers if you like – maybe even in colour – and wrap around. Collate your photocopies (compile them together in order for each edition of your comic), fold, centre-staple them if you wish and cut off any excess paper according to your other crop marks. You have your completed Manga, ready for circulation.

INTERNET PUBLISHING

The other way you can get your Manga seen is to put it up on the Internet. Although some readers prefer their comics with staples, and have a hard time concentrating on reading lengthy stuff on-screen, that is unlikely to be a universal problem. Comics on the Web have the advantage of a potentially huge audience – they might well be read all around the world! Check out *Reinventing Comics*, a book by Scott McCloud, to get the lowdown on what the future may hold for the comics format on the Web. There are moves to start circulating downloadable comic strips that you read on the screens of mobile phones! Who knows where that might lead...

CHAPTER 11

LOOKING TO THE FUTURE

FIND OUT MORE ABOUT WHAT THE FUTURE MIGHT HOLD FOR MANGA — AND FOR YOU.

LOOKING TO THE FUTURE

anga is most definitely going to play a major role in our cultural future. Its wide-ranging influence is already being felt.

When the current generation of Manga readers begin to filter through as the taste makers, film directors, writers and artists of tomorrow, it will seem the very language of the future. Similarly, as the readers of *shonen* and *shojo* grow and begin to demand different sorts of material, the range of titles and genres will proliferate.

Western-originated Manga will no doubt end up being different from Japanese Manga – a further mutation of the hybrid. It will probably take on other forms and formats, including hi-tech variants. Down the line, there is a distinct possibility that full-colour Manga will become the norm. They will look much like anime on paper. The popularity and availability of anime itself, hand in glove with Manga, will grow and grow.

Where do you fit into all this? Well, even as a reader of Manga, a world of entertainment awaits that is only going to get bigger and bigger. Or, you never know, you may well end up contributing yourself in some way – as a writer or artist, or even a full-fledged *mangaka*. But there are also many other types of jobs where your developing skills may come in useful.

CARTOONIST

If you have a talent for humour in particular, the skills of Manga can come into play. The ability to sketch the world quickly and convincingly and populate it with hyper expressive oddball characters is central to both. The pages between unfolding sagas in the Japanese weekly titles are filled with what's called *4-Koma* – quickfire gag strips in the style of newspaper comics. The mobile phone comics of the future are most likely to take on this form.

STORYBOARD ARTIST

Storyboarding for advertising and film media is a natural transition from the storytelling skills of Manga. Careful storyboarding of a complex sequence immediately puts director, cast and crew on the same page and saves millions of dollars. Many comic artists find employment as storyboard artists (Steve Skroce on *The Matrix* is just one of many examples). The money is good – but unless it is as a DVD extra, all their work usually goes unseen by the world at large!

ILLUSTRATOR

Fashionable styles come and go in illustration, but no doubt the influence of Japanese Manga is already creeping in. Many comic artists also work as illustrators in a cartoon style, doing book, magazine and record covers as well as lucrative advertising campaigns, corporate identity and logo design. Often they supplement their incomes by doing illustration – so that they can indulge themselves by making another comic book!

GRAPHIC DESIGNER

Just as for illustrators, by being as versatile as possible and keeping your options open, you will make yourself more employable. It may feel like wearing more than one hat – but it allows you to do the stuff you really want to do, in between the jobs you have to do in order to pay the rent. By maintaining a careful balance, you keep the flame alive – or else you might wake up one day to find you've forgotten why you are doing what you are doing!

ANIMATOR

This job involves many different skills, including character design, drawing figures in motion and good pacing. Anime will continue to explode in popularity, as will all other forms of animation, meaning a bright future ahead in this field.

FILM DIRECTOR

Many leading film directors, past and present, are acknowledged fans of comic books. Federico Fellini, M. Night Shyamalan, Robert Rodriguez, George Lucas, Ang Lee, Bryan Singer and a great many more. Top European film-makers – Pedro Almodóvar, Jeunet and Caro, Enki Bilal – all began their careers in comics, not to mention all the many Japanese *mangaka* who have gone on to direct anime and live-action films based upon their own strips!

CONCEPTUAL ARTIST AND/OR CHARACTER DESIGNER

In film, in computer games, and all points in between. If you are good at creating entire worlds from the ground up, everybody will want to know you.

FUTURISTIC VILLAIN
by Bram Lee Chin Horng

I wanted to create a futuristic-style villain to show how, by using simple shading and lighting techniques, you can really add depth and a sense of drama to your artwork.

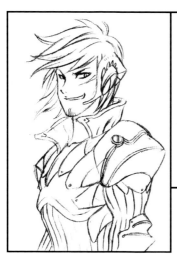

Step 1: I started by doing a rough pencil sketch of the character.

Step 2: Next I outlined the sketch using a mechanical pencil, picking out the details and preparing for the inking stage.

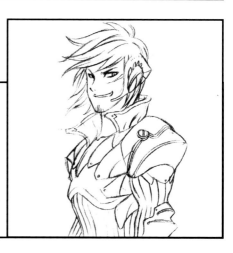

Step 3: I inked over the pencil outline on another layer of paper using a lightbox and a fine-tip waterproof black pen.

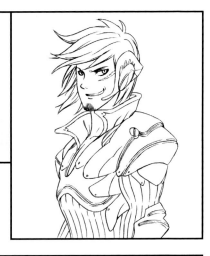

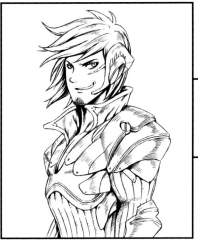

Step 4: I inked in the details, adding texture to the illustration.

Step 5: I began adding tone to the darker parts of the figure.

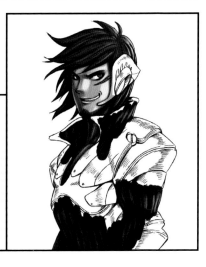

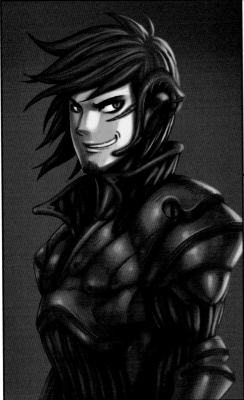

Step 6: I designed lighting for the character, assuming that the main light was coming from the back, and added much of the colour.

Step 7: I added a background consisting of some sort of 'aura' to focus attention on the character.

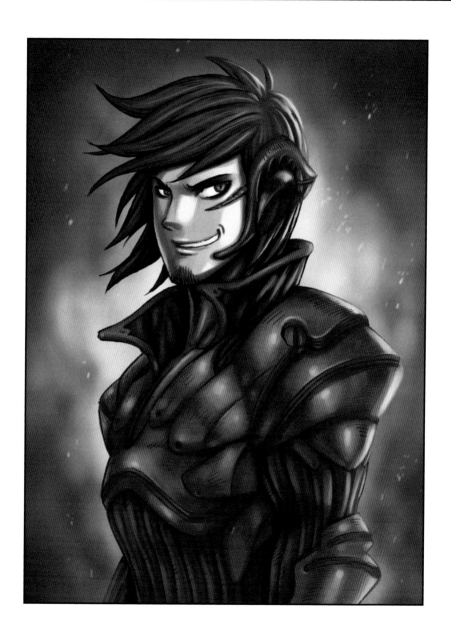

MANGA ANIMALS
by Elli J Puukangas

A great understanding of anatomy is important when drawing Manga; even more so when drawing animals.

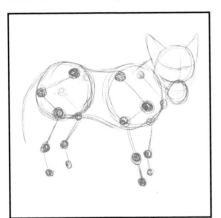

Step 2: I started adding 'flesh' to the skeleton. I drew in the details and the face.

Step 1: I started by drawing two circles, and sort of a bean-like body. I added small circles on the bean-skeleton, where the legs and joints are going. Next I added two circles for the head and the position of the muzzle.

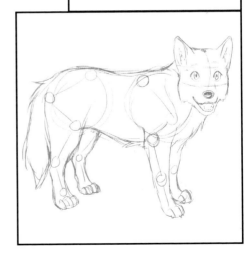

Step 3: At this point, you can either scan the picture and start inking it digitally, or you can choose to continue drawing traditionally. With either mechanical pencil or ink, start drawing on top of the sketch.

Step 4: I erased the sketch, giving me a clean inking of the dog. You can add more details to the fur now, and draw the lines in the direction of the growth to make it look more natural.

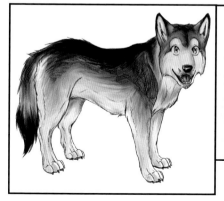

Step 5: When colouring the dog, remember to make sure the brushstrokes go in the direction of the fur growth. Use different shades of greys and browns, if you want the canine to look more realistic.

MANGA PORTRAIT
by Maguro LiLi

After mastering the creation of a classic *shojo* character, bring your character to life by using shading and lighting techniques.

Step 1: First I sketched out my character using basic lines just to provide a foundation.

Step 2: Once the character shaping was done, I cleaned up some of the unnecessary lines before moving to the next stage to avoid confusion during shading.

Step 3: Next I started applying the basic contrast as a guide to a further level of shading. It is really important to understand where the light is coming from to create a realistic 3D effect.

Step 4: Once the lighting direction was confirmed, I started shading slowly. Remember, patience is key.

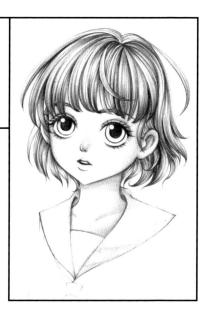

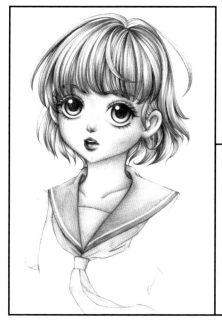

Step 5: I applied the second level of shading, which is darker. At this point, keep in mind where you should apply the darker tone... Do not forget the direction of the light!

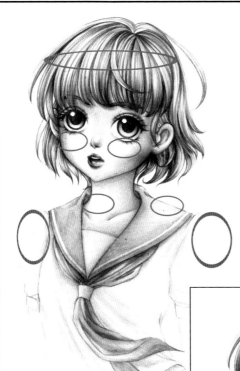

Step 6: I was nearly there: I already had the shadow part, but what was missing, still, was the lighting effect. Carefully, I erased the parts where I wanted light to bring the character out.

GLOSSARY

anime: Short for 'animation' in Japanese. Outside Japan, used to refer to Japanese animation.

bishōjo: 'Pretty girl' Manga.

chibi: An anime character, the word means 'little'. Chibi characters are usually small and cute.

foreshortening: The 3D effect that makes flat, 2D images on paper appear to leap out from the page or appear as if they are vanishing into the distance. Used to add dramatic power to comics.

gekiga: Drama images or 'graphic novel'.

gutter: The gap between two panels. In American comics they tend to be of uniform size or width. In Manga, as well as in many European comics, vertical gutters between panels are often thinner than horizontal ones. This encourages correct reading order.

hana-ji: An element of Manga drawing used to signify lust – more than a simple nosebleed.

kaiju: A popular genre of Manga which includes monsters.

layout: The formal arrangement of panels on a page, as well as the arrangement of various elements within each panel.

manga: Comic strips, Japanese-style.

margin: The area toward each page edge.

mecha: Robot genre Manga, featuring robot characters.

motion blur: The result of a technique used to blur the edges of an object so they lose their definition and become less distinct from their surroundings.

page: A single unit, usually only part of a longer sequence or story. Two pages seen together form a spread.

prores: Short for Professional Catch Wrestler – this is a genre about pro wrestling.

seinenshi: Young men's magazines aimed at adult males in their twenties and thirties.

shojo: Mood comics that centre on the expression and suppression of emotion. Popular genres include romance, school, magic, costume drama and comedy.

shonen: Principally adventure comics including sports and fantasy action, this genre of Manga is targeted at juvenile males.

speedlines: A drawing technique used to enhance sequences and signify motion, emotion, action and dramatic mood shifts.

spread: Two facing pages seen together.

thumbnails: Your Manga story panels and pages sketched out using simple little drawings and jotted notes for dialogue and action. Thumbnails are personal production drawings, not necessarily intended for others to understand.

CREDITS

T = top, L = left, C = centre, B = bottom, R = right, F = far

7 © Sankei/Getty Images; 9L © Photos 12/Alamy; 9R, 140TL © Andy Watson; 14 Cooking Papa 'Daddy the Cook' © Tochi Ueyama, Kodansha 1986; 22T ('Oh My Goddess!') © Kosuke Fujishima; 22CL ('The Silent Service') © Kaiji Kawaguchi; 22CR ('Carefree Tales') © Yasuji Tanioka; 22B ('Clouds of the Deva King') © Hiroshi Motomiya; 23T, 24 © Shutterstock; 29T Furasshu 'Flash' © Masashi Tanaka; 29BL, 91BR YAIBA © Gosho Aoyoma, Shonen Sunday Comics 1991; 41L Giant Baby © Carl Flint/Kodansha 1993; 41R © Bill Barker; 50 (bishojo) Love Planet © Taro Matsumoto; 50 Aishiteru ('I love you') © Dai Morimura; 50 (salaryman) © Kenshi Hirokane; 50 ('Osaka Scrooge') © Yuli Aoki; 51L ('From Eroica With Love') © Aoike Yasuko/CMX/Akita Publishing company Ltd; 51C ('Daddy the Cook') © Tochi Ueyama/Kodansha 1986; 51R, 150 ('Sumo Champ Harimanada') © Kei Sadayasu, Kodansha; 52L REGGIE © Guy Jeans/Kodansha 1992; 54 Kiseijyu ('Unwilling Host') © Hitoshi Iwaaki; 55T Adolf © Osamu Tezuka; 55C Hazard Edizioni © Osamu Tezuka; 55B, 76L Lone Wolf © Goseki Kojima/Kazuo Koike; 62 Sazan Aizu © Yuko Takada 1988; 76R © Oscar Zarate; 77T, 87BL Hadashi no Gen © Keiji Nakazawa; 83T Par-Peki-no-Chichi © Yu Azuki; 87LC ('I love you') © Dai Morimura; 94BR, 95R Tetsuo The Iron Man © Yasuhito Yamamoto; 101TL DrAgon heAd © 1995-1998 Mochizuki Minetaro; 102 AKIRA © Katsuhiru Otomo/Akira Committee 1988; 114BL 'From Miyamoto to You' © Hideki Arai/Kodansha; 115TR Same Difference © Derek Kirk Kim; 119 ('Ghost in the Shell') © Masamune Shirow; 124, 125, 126, 127, 128, 129T © 2002-2004 WYM&RAN/Wooti Ltd; 129CR, 129B © Craig Conlan; 130, 131, 138, 139 Warpath © Ed Hillyer (ilya-San)/Bambos Georgiou; 140BL, 160 (Wrath of the Ninja) Images © 1994 Yonin Gumi, TASS and the Society for the Promotion of Japanese Animation; 145, 146, 147 © Wing Yun Man; 161T Mazinger Z vs. Debiruman ('Devilman') © Toei Animation; 161TR SD Gundamu ('Super Deformed') Mobile Suit Gundam © 2004 Sotsu Agency/Sunrise; 162 Patlabor © Masami Yuuki/Headgear; 163 © Brian Ralph; 168T Zokubutsuou 'King of the Moneymen' © Hitoshi Fujisaki/Jiro Tsuruya; 168B © Shutterstock; 170 Daisy © 2004, Wing Yun Man; 201 © Andrea Bruno/Schizo.

Background images from Shutterstock and iStock.

Project artist credits:

1, 3, 56, 57, 58, 59, 80, 81, 211, 214 © **Bram Lee Chin Horng**

88, 89, 132, 133, 134, 135, 215, 216 © **Elli J Puukangas**

70, 71, 72, 73, 92, 93, 106, 107, 108, 109 © **Irene Strychalski**

46, 47, 156, 157, 158, 159, 217, 218, 219, 220 © **Maguro LiLi**

All other artwork, unless otherwise identified, by and © **ILYA**

INDEX

A

abstract effects 79
abstract expressionism 171
abstract camera angles 80
action
 in panels 200
 sequences 70–3, 74–5
 shots, *shonen*-style 152–3
American superheroes 38
animals 215–16
animators 210
anime 25, g221
 artwork 96
 characters, *Chibi* 23
 colour style 102–3
art paper 180
art supplies 15
Ashita No Joe 52
Astro Boy 6, 8, 9
atmospheric effect 98

B

babies, stereotypes 41
backgrounds 72, 110–19, 213
 inking 195
Barker, Bill 41
biography titles 55
bird's-eye view 69
bishōjo titles 50, 144–5,
 146–7
bishonen 144
Bishoujo Senshi Sailor
 Moon 53
black and white artwork 8,
 25, 96
blank eyes convention 94
bleed 65
blue pencils 15, 33
board games titles 51
body
 drawing 91
 geometry 38
 proportions 37–9
 shapes 150–1
boys comics 52
Bruno, Andrea 201
brush pens 106, 136
brushes 16, 104, 136
brushing, *kanji* 142–3
BunQ 45

C

camera angles 68
 abstract-yet-cinematic
 80
 multiple 74
captions 63
careers 208–10
cel-painting 102–3
chairs 18
chambara 55
character designers 210
characters
 copyright 164
 creating/designing
 30–47, 122–65
 recognisable 32–3
chibi 12, 44–5, g221
 anime characters 23
chibi-style colour turns 125,
 127
childlike appearance 28, 41,
 44
choreography 79–81
clay heads 148
close-ups 28
 see also ultra close-ups
clothes 138, 139, 140–1
CMX (DC Comics) 53
CMYK mode 100, 101
collaboration 202
colours
 complementary 101
 flat, adding 57–9
 full 25
 theory 100
composition 78–9
conceptual artists 210
confident line 203
Conlan, Craig 129
 Kittylips robot 45, 162
construction frames 151–5
copyright, characters 164
creature features 128–9

D

Dalí, Salvador 114
depth, creating 112
detail, and pacing 77
dialogue panels 67
down-shots 37
Draconis character 126–7
drawing boards 19
drawing kit 15–18
dry brush effects 104

E

ears 35
eight-page sequence
 174–201
emotions 168–71
emotive speedlines 187,
 188–9
enlarging 182, 187
Erwil character 132–5
establishing shots 68
extreme close-ups *see* ultra
 close-ups
eyebrows, emotions 168
eyes
 big 28, 43
 blank, convention 94
 emotions 168

F

faces
 angles 36–7
 delicate work 72
 emotions 168–71
 proportions 32, 35
 simplifying 148–9
feeling/mood
 communication 40
felt-tips 136
female fighting character
 156–9
fight scenes 80–1
figurines 16, 38
film directors 210
flat colour 57–9
focus, panels 192–3
folds 141
foreground, inking 195
foreshortening 27, 90, 92–3
fractured layouts 66
full-colour Manga 208
future
 manga 208–9
 mecha 163

G

gekiga, (drama images) 201
genres 48–59
geometric shapes, building
 blocks 90, 91, 153
geometry, body 38
Gojira (Godzilla) 54
graphic designers 208
graphic novels 191
graphics software 17

greyscale tone 97
gutters 63, g221
 significance 74

H

hair, big 42
halftone effects 97
hana-ji convention 94, 95, g221
head and shoulders shots 69
heads
 angles 36–7
 drawing 91, 148–9
 shapes 34
 size 32, 41–2
high angle view 69
highlights 58, 81
Hiragiku (Crazy Daisy) 170
Hissy 45, 128–9
historical biography titles 55
history 6–13
Hokusai, Katsushika 12, 170
horizon lines 116
hyena demon 39
hyper reality 114–15

I

impressionistic tone 98
inking
 layouts 187, 191–6
 pencil preparation 190
 strokes 136–7
 techniques 105
inspiration, finding 165
irregular layouts 65–6

K

kaiju (monster) 54, g221
kanji characters 53, 83
 forming 142–3
kanji Shi Ki (historical biography) titles 55
Kitsune Tales 112–13
Kittylips robot 45, 162
Koike, Kazuo 55
Kojima, Goseki 55
Kumo ni Noru 22

L

lateral drift 91
layouts 62–7, g221
 for sequences 176–7
layout paper 180
Lee Chin Horng, Bram 56

fight scene 80–1
 futuristic villain 211–14
Legend of the Swordmaster Yaiba 29
lettering 63, 82–3, 183
life, sketching from 33
life skills titles 51
light and shade 98
light sources 195, 213
 establishing 107
 effect 98–9
 reflection 47, 158
lightboxes 182
LiLi, Maguro
 female fighting character 156–9
 mascot art 46–7
 portrait 217–20
line thickness 190
linework 190–9
 tone 97
linking panels 176
live art area 65
Lone Wolf and Cub 76
low angle view 69

M

mah-jongg titles 51
manga revolution 50
maquettes 16, 38
margins 65, g221
markers, colour 107
Mary Hell character 130–1, 148, 150
mascot art 45–7, 128–9
Masking tape 17
mecha 12, 47, 54, g221
 construction 160–3
 inking techniques 105
Mechagodzilla 54
mechanical tone 97, 196–7
mechanisms, real 160
Mentary Brothers 171
merchandise 45
metallic finish techniques 105
midground, inking 195
monsters 54
montage, action 74
motion blur 81, g221
 how to 87
motion, figures 150–2, 154–5
mouths, emotions 168

movement 79–81
 and body shape 39
multiple camera angles 74

N

non-linear narrative 62
nose bubbles 94
nosebleed (hana-ji) convention 94, 95, g221

O

one-colour printing 25
one-point perspective 117, 118
otaku (obsessive) 144
Otomo, Katsuhiro, *Akira* 102
outlines first 192–3

P

pace
 changes 76, 77
 sequences 178–9
 reading 74–7
pages g221
 design 64–7
 layouts 62–7, 181–201
 order 8, 13
 sizes/proportions 181
pagination 204
palette colours 100
panels 63–7
 borders 71
 reading order 183, 185–6
 sequences 176–9
paper 17
 for final layouts 180
Parasyte 54
Patlabor: Mobile Police 54
pattern makers 97
pencils 32
 layouts 187–91
 shading 190
 sketch stage 56–7
pens 15, 136
perspective 80, 116–19
Photoshop 17, 59
pixelate effects 97
planning, lettering 83
points of view 68–9
Pokémon 45
Popeye 6
poses, character 156
prores 55, g221

publishing 204–5
Puukangas, Elli J
 Erwil character 132–5
 animals 215–16
 action 88–9

R
Ralph, Brian, *Fireball* 162
reading pace 74–7
realism, using 114–15
recognisable characters 32–3
reference materials 18
reflection 47, 158
regular layouts 64
rimlights 81
robot genre 54
 creating 46–7, 160–3
romance 50
rough layouts 177
roughened surfaces 105
round objects, shading 47

S
salaryman titles 51
satire 55
SCHWA alien graphics 41
scripts, using 202–3
seinenshi 55, g221
self-publishing 204–5
sensais (master artists) 76
shading 47, 158
shadows 195
sheets, pagination 204
shines 104–5
Shinohara AV-98 162
Shinra bat-cat 126, 128
shojo 12, 53, g221
 characters 56–9
 layout 65
 sketches 124, 126
 styling 131
shonen g221
 action shots 152–3
 characters 99
 layout 65
 styling 131
 titles 52
shonen ai comics 50
shots 68
simplicity 120–1
 features 148–9
situation/resolution 202
skeleton figures 152, 154–6
 animals 215

sketches and turns 124–7
sleep convention 94
sound effects 63, 79, 83, 187, 188
 panels 67
 placement 71
special effects 84–109
speech balloons 63, 71, 82
 creating 184
 inking 191
 placing 183–4
speedlines 26, 81, g221
 emotive 187, 188–9
 how to draw 86–7, 89, 92–3
sports titles 51
spreads 174–5, g221
starburst convention 95
stick figures 152, 154–6, 215
story, eight-page 174–201
storyboard artists 208
storyline, sequences 178–9
storytelling 60–83, 172–201
Strychalski, Irene
 action sequence 70–3
 art of colour 106–9
 speedlines 92–3
 styles 20–9
sweating convention 95
symbols 94–5
sympathetic characters 40–5

T
tankubon 96
Tetsuo, the Iron Man 95
textures 104–5, 195
Tezuka, Osamu 6–7, 55
3D effects 27
thumbnails 66, 92, g221
 action sequence 70
 colour scheme 106
 scripting 202
 sequences 176–7
tiers 63
tints, greyscale 97
Tokyopop 53
tone 17, 25, 196–9
 applying 96–7
 effects 98–9
trace paper 180
transitional panels 77
transmogrified characters 32
Trudy and Kurokumo 44
turns, sketches 124–7

two-point perspective 117, 118
two-tone colouring 103
'typical' style 40–5

U
ultra close-ups 69
 how to draw 91
up-shots 37

V
vanishing point, speedlines 92–3
vertical reading, balloons 83
view points 68–9

W
Warpath characters 130–1, 138–9, 148–50, 174–9, 185–200
wash tone 97
Watson, Andi
 Samurai Jam 140
 Skeleton Key 113
Western-originated manga 208
Wildside character 130–1, 138–9, 185–200
Wing Yun Man 44
 dark *bishojo* 146–7
 Hiragiku (Crazy Daisy) 170
 Telephone Ice Cream 124–7
 Wing character 124–5
work space 15, 18–19
worlds, creating 110–21
worm's-eye view 69

Z
Zarate, Oscar 76
zasshi format 52, 102
zoom-in shots 69